CINEMASTROLOGY

CINEMASTROLOGY

THE MOVIE LOVER'S GUIDE
to the SUN, the MOON, and the STARS

STELLA WONDERLY

illustrations by ZOE WODARZ

Running Press
PHILADELPHIA

Running Press
Hachette Book Group
1290 Avenue of the Americas, New York, NY 10104
www.runningpress.com
@Running_Press

Printed in China

First Edition: June 2020

Published by Running Press, an imprint of Perseus Books, LLC, a subsidiary
of Hachette Book Group, Inc. The Running Press name and logo is a
trademark of the Hachette Book Group.

The Hachette Speakers Bureau provides a wide range of authors
for speaking events. To find out more, go to www.hachettespeakersbureau.com
or call (866) 376-6591.

The publisher is not responsible for websites (or their content) that
are not owned by the publisher.

Photography credits on page 231.

Print book cover and interior design by Susan Van Horn.

Library of Congress Control Number: 2019952573

ISBNs: 978-0-7624-6962-8 (paperback), 978-0-7624-6960-4 (ebook)

1010

10 9 8 7 6 5 4 3 2 1

For those treasured few who know and
understand the Cancer-Aries-Capricorn
soul behind Stella Wonderly.

CONTENTS

Welcome to
CINEMASTROLOGY

*"We are born at a given moment, in a given place,
and, like vintage years of wine, we have the qualities
of the year and of the season of which we are born.
Astrology does not lay claim to anything more."*

—CARL JUNG

*"We think of stars as celestial beings.
And once in a while, they smile at us from the
pages of **People** magazine."*

—A. E. HOTCHNER

WE LIVE IN AN AMAZING AGE. Never before has humanity had so much astro-logical information at its fingertips. The number of websites, blogs, podcasts, videos, and software devoted to the study of the stars is unprecedented. Similarly, we have access to more movies now than ever before. The majority of Hollywood's staggering one-hundred-plus-year output—along with international and independent films—is avail-able for browsing, streaming, and downloading at the click of a button. Not to mention the deluge of celebrity that confronts us from all corners, all day and all night.

For movie fans and devotees of astrology, this wealth of information and enter-tainment makes us feel like kids in a cosmic candy store. It's wonderful—but it's a little

overwhelming! Who has time to absorb every detail about the heavenly bodies that influence our daily lives? And who could possibly watch every single motion picture out there?

Dear reader, welcome to Cinemastrology: the art and the science of selecting movies based on your zodiac sign. As a celestial cinemaven (both an astrologer and a movie expert), I have done the hard work for you. Using an astute understanding of what makes each of the twelve signs tick, combined with a vast knowledge of classic and contemporary cinema, I have created the ultimate guidebook to the stars in your horoscope and the stars on the screen. And it's easy. All you need is a birthday and a passion for film entertainment.

Movies, just like everything else on this planet, fall under the auspices of the celestial orbs that travel across our skies. For millennia, stargazers have looked upward to find patterns that relate to their lives. In fact, astrology predates recorded history. Because the sun, the moon, the planets, and the stars move in predictable paths, early thinkers in Babylon, Egypt, and Greece posited that the movements of these heavenly bodies coincided with earthly events. "As above, so below" became the credo for the connection between the glimmering night skies and the ground beneath our feet.

The zodiac (a word that means "circle of animals") originated through years of observation. Past civilizations noticed that those born around the same time of year shared some remarkably similar personality traits. Using twelve major constellations as guideposts, the ancients devised a system of interpretation that's been refined over the centuries into modern astrology. Today, we have an accurate idea of the ways in which the cosmic energies influence our world and even our very personalities. A common misconception is that astrology suggests that we are controlled by forces beyond our free will, but this isn't how it works. Longtime Hollywood astrologer Carroll Righter put it best when he said, "The stars impel, they don't compel. What you make of your life depends on you."

If you're new to astrology, you're about to meet a glamorous all-star cast. The ten celestial bodies used in basic astrology are: the sun, the moon, Mercury, Venus, Mars, Jupiter, Saturn, Uranus, Neptune, and Pluto. Each planet rules (influences) at least one of the twelve signs: Aries, Taurus, Gemini, Cancer, Leo, Virgo, Libra, Scorpio, Sagittar-

ius, Capricorn, Aquarius, and Pisces. Every sign relates to one of the four elements: creative, passionate fire; practical, steady earth; cerebral, sociable air; or emotional, intuitive water.

Astrology goes much deeper than this. Those who are already astro-experts know the complexities of ascendants, aspects, houses, quadruplicities, and so forth. For the purposes of this book, though, we will stick to sun signs.

The sun is the force that goes the farthest toward defining our identity. It's the cornerstone of popular astrology. The sun is not the only factor in our astrological makeup—far from it! Each person has a unique birth chart based on his or her exact time and place of birth. But the sun sign is the one everyone knows. It's the simplest to determine, and the one we give when anyone asks, "What's your sign?" Since British astrologer R. H. Naylor began popularizing sun signs in 1930, the population of the Western world has been reading horoscopes in magazines and wearing Leo medallions around their necks. This is sun-sign astrology at work.

Hollywood—the film business and the community of those who work in it—has a history of conjoining the stars. In the 1930s, a craze for astrology emerged in movies like the horoscope-themed thriller *Thirteen Women* (1932), and *When Were You Born* (1938), starring Anna May Wong as an astrologer. The cycle continued into the 1940s with *The Heavenly Body* (1944), with Hedy Lamarr as an astronomer's wife who is a closet astrology addict. The experimental 1970s gave us the cult oddity *The Astrologer* (1976), featuring Craig Denney as a carnival mystic–turned–famous psychic. More recently, the crime drama *Zodiac* (2007) recounts the manhunt for the astrology-obsessed serial murderer dubbed the Zodiac Killer.

Off the screen, hordes of celebrities (Marlene Dietrich, Grace Kelly, Cary Grant, Lana Turner, Tony Curtis, and Ronald and Nancy Reagan, to name a few from the past) have consulted astrologers to determine the most auspicious dates for career decisions, weddings, and even conceiving children. In the 1950s and '60s, Tinseltown saw a trend for zodiac parties, at which no names were used, only astrological designations: "Miss Aries, meet Mr. Libra."

For those of us noncelebrities in the audience, it's natural to observe links between movies and the people who make them. Astrology offers a blueprint for these con-

nections. Obviously, filmmakers put their own personal stamps on their creations. An Aquarius director (John Hughes, for example) will not invariably make films that appeal to all Aquarius-born viewers, but will often make a typically Aquarian film (*Ferris Bueller's Day Off* [1986], for example).

The astrology of the performers also factors in. Actors (especially big stars with clout) rarely fall into movies by chance; they are either drawn to the story due to personal reasons, or they were cast because they naturally exude some attributes of the characters they play. It's no accident that comedian Jim Carrey (a Capricorn born on January 17) played comedian Andy Kaufman (also a Capricorn born on January 17) in the biopic *Man on the Moon* (1999). Screen actors and actresses shape the tone and flavor of a movie with their distinct personas, leaving fingerprints on the finished product as much as a writer or director does.

In their personal lives and in public interviews, celebrities (just like the rest of us) exhibit qualities inherent in their zodiac signs. It can be fascinating to witness. Is it any wonder, for instance, that Tom Hanks once said: "I always look up at the moon and see it as the single most romantic place within the cosmos." No wonder at all, considering he is a Cancer, a romantic sign ruled by the moon. When asked if she thought astrology was legitimate, Gemini Joan Collins replied, "Half of me believes, the other half doesn't." Spoken like a true twin. Some stars even directly attribute their personas to their sun signs, like self-critical Virgo-born Keanu Reeves, who has confessed, "I'm a Virgo; it's in my sign to be hard on myself."

A note about cusps: Those born on the cusp (the day the sun changes from one sign to another) are not a combination of both signs—they are one or the other, depending on their exact time of birth. (Also, the dates for each sign can shift slightly from year to year, so if you're born on the cusp, it's a good idea to have your birth chart drawn up to see where exactly your sun falls.) The cusp-born, however, are typically imbued with a few characteristics of their neighboring sign. Scarlett Johansson, born on November 22, is a fiery, outspoken Sagittarius lady, but she clearly exhibits some seductive Scorpio traits as well.

The book in your hands will illuminate the sun-sign secrets of some of the cinema's biggest stars, movies, and moviemakers. But the main star of *Cinemastrology* is you!

Why not let the celestial signposts guide you to your next cinematic adventure? You'll find new flicks, rediscover forgotten favorites, make film-viewing plans with a friend or date, see familiar movies from a new perspective, and even learn a few things about yourself along the way.

What unique qualities lead you to enjoy the movies you enjoy? What titles turn a Taurus on? What genres bring joy to a Gemini? What screenings star Sagittarian celebrities? In the pages that follow, I will unearth all of these mysteries and more.

No matter what sign you were born under, to get the most from this book, it's best to read all twelve sections. After all, a great movie will appeal to a wide audience, so it's safe to assume that you'll find appropriate recommendations in every corner of the zodiac.

Happy viewing! See you among the stars.

—Stella Wonderly

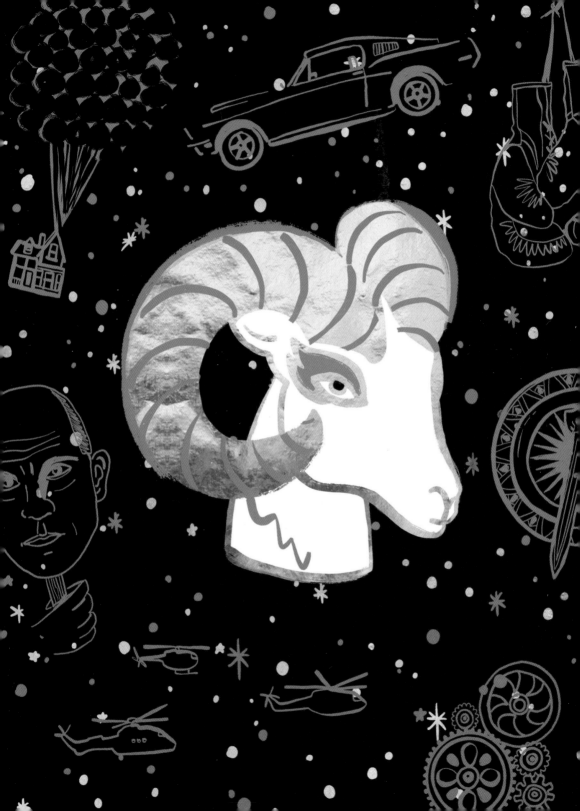

ARIES

MARCH 20–APRIL 20

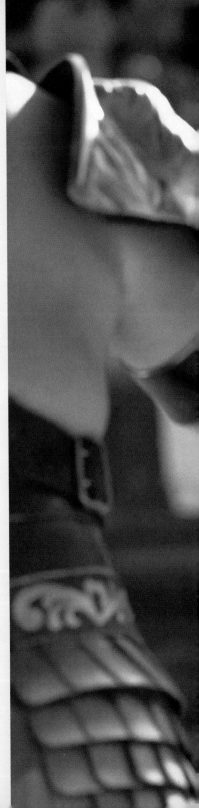

THERE'S A REASON THAT RAMS HAVE HORNS—

they confront, they butt, they push until they get their way. Those born under Aries the ram, a fire sign ruled by the warrior planet Mars, are bold, assertive trailblazers who like to do things first. (They made it to the number-one spot in the zodiac, didn't they?) Because the spring equinox kicks off the astrological year, those who entered the world during the first burst of springtime are the babies of the zodiac, forever young, eternally playful, and unceasingly curious. This youthful energy charmingly compensates for any pushiness or aggression Aries natives may occasionally display when they step on a few toes to get to the finish line first. Their need to win the race of life means they're always in a hurry. If they lose, expect to see flashes of their fiery temper. But they usually grab the gold.

Naturally, rams like a lot of action in their lives and on the screen. Aries, this doesn't mean your taste is confined to Chuck Norris movies (not that there's anything wrong with that). It means a long, slow, cinematic talk-fest won't have you dashing to the multiplex. An exciting story and a fast pace make your pulse race. Throw in an impressive display of physical strength and you're in heaven. Think of Steve McQueen (an Aries) in *Bullitt* (1968), sliding into his Mustang and pushing the pedal to the metal in a daring car chase; or Russell Crowe (another Aries) reluctantly but brutally battling his opponent to the death in *Gladiator* (2000); or Gal Gadot stopping bullets in their tracks as she struts

OPPOSITE: Russell Crowe embodies the warrior planet, Mars, in *Gladiator*.

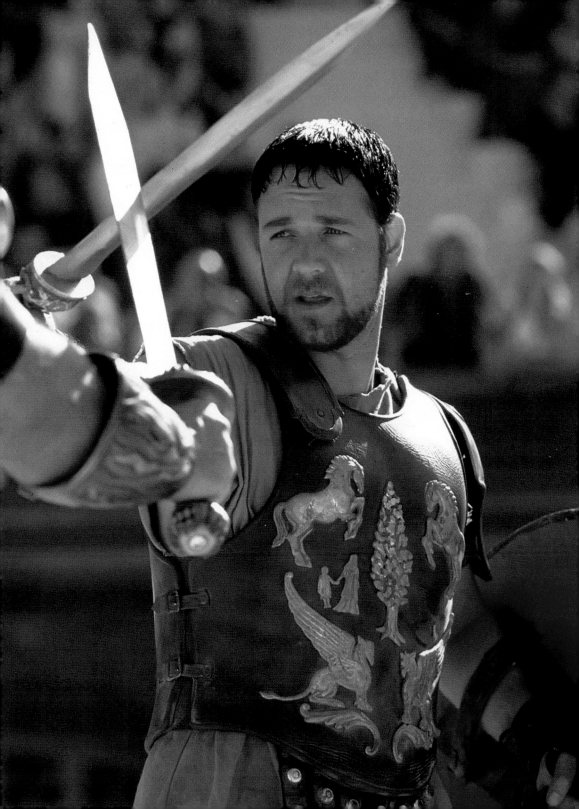

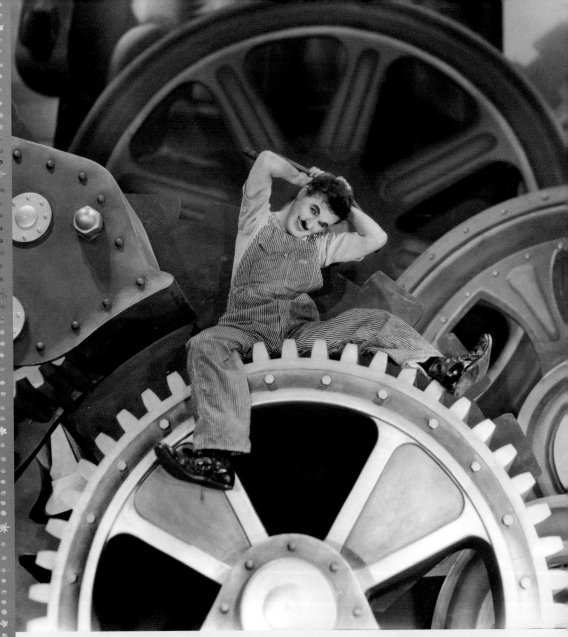

Charlie Chaplin, an Aries, demonstrates his physical comedy skills in *Modern Times*.

across no-man's-land in *Wonder Woman* (2017). War movies also fall into your realm, Aries. Check out *The Dirty Dozen* (1967), *Patton* (1970), and *The Hurt Locker* (2008) to get your fix of battlefield brutality.

But not so fast. Your reputation as a hot-blooded brawler is only half the story. Each sign of the zodiac governs a different part of the body, and Aries's domain is the head and the brain. That means you're a thinker as well as a fighter; you have a side that's more cerebral than others often suspect. Thought-provoking tales about the wonders of the human mind—*Being John Malkovich* (1999), *A Beautiful Mind* (2001), and *Arrival* (2016), to name a few—stimulate those Aries brain cells.

Fire fuels creative passions. As a fire sign, Aries, you sizzle with creativity, and your mind is overflowing with ideas (you'll notice that the glyph for your sign looks like the horns of a ram, but also resembles a flowing fountain). So you may appreciate innovative animation along the lines of *Up* (2009), skillful physical comedy as performed by the masterful Charlie Chaplin in *Modern Times* (1936), and even a good, splashy musical, à la the savage, sultry *Chicago* (2002)—anything that moves, takes unexpected turns, and not only grabs your visual attention, but holds it.

How has the sign of Aries impacted the art of motion pictures? Take a look at the work of Francis Ford Coppola, Roger Corman, Stanley Donen, Curtis Hanson, Akira Kurosawa, David Lean, Kenny Ortega, Quentin Tarantino, and Edgar Wright—a few Aries filmmakers who have set movie screens on fire with their thrilling, adventurous, sometimes violent and controversial, but always entertaining, visions. In addition to the suggestions below, you may want to explore the output of these directors, observing how their ram energies are vibrantly expressed through the medium of film.

⇒ ARIES HIDDEN GEM ⇐

Did you know that Aries actress/producer/mogul Mary Pickford excelled in physical comedy during her years as a major silent movie star? Check out "Little Mary" in *Little Annie Rooney* (1925), a rough-and-tumble laugh-fest that Pickford not only starred in (playing a twelve-year-old at age thirty-three!), but wrote and produced.

Aries Adrenaline Fests

APOCALYPSE NOW
(1979)

Only an Aries (director/producer/cowriter Francis Ford Coppola, born April 7) could take *Heart of Darkness* (Joseph Conrad's 1899 literary critique of colonialism), place it smack in the middle of one of America's grisliest and most dismal conflicts, and end up with such an audaciously engaging epic, infused with black humor and a rockin' soundtrack to boot. In every scene, the horror of war meets the style of the '60s, as seen through the lens of the late '70s. Enduring destructive weather, budgetary catastrophes, the Aries temperament of megastar Marlon Brando, and the near-fatal heart attack of lead actor Martin Sheen, Coppola not only delivered a masterpiece but set a trend with *Apocalypse Now*, one of the earliest entries in the Vietnam War–movie genre. It's a head trip tailor-made for the headiest of signs.

KUNG FU HUSTLE
(2004)

Talk about fast-paced. Stephen Chow's irreverent crime/action/comedy/martial-arts mash-up leaves no space for a single second of boredom. It's a Jackie Chan movie meets *Moulin Rouge!* (2001) meets *The Matrix* (1999)—yet it creates a unique world all its own, a video-game-ish version of 1940s China in which heroic Sing (Stephen Chow) aspires to be a major badass. Beneath the butterfly kicks and the cartoon-like surface, *Kung Fu Hustle* cannily explores some deeper ideas about society and destiny. The more mature Aries audience will appreciate the statements about karma and standing up to oppression, while the younger crowd will be knocked silly by the visual fireworks. Appealing for rams of all ages.

OPPOSITE: Francis Ford Coppola and Martin Sheen make *Apocalypse Now* in the Philippines.

Aries Date Movies

THE GETAWAY

(1972)

Aries, you can canoodle with the best of them—as long as you don't have to sit through a predictably sappy romantic drama. For your next date night, cozy up to outlaw Steve McQueen and his impulsive wife Ali MacGraw as they rob a Texas bank and speed toward the Mexican border in Sam Peckinpah's eight-cylinder chase flick. Fun fact: Lead actor and actress fell head-over-heels in love and left their spouses for each other during the making of this film; they got divorces and married the following year. You guessed it—McQueen and MacGraw were both born under the sign of the ram. You'll witness their chemistry firsthand in *The Getaway*, along with a few explosions, gobs of gunplay, and a supercool score from Quincy Jones.

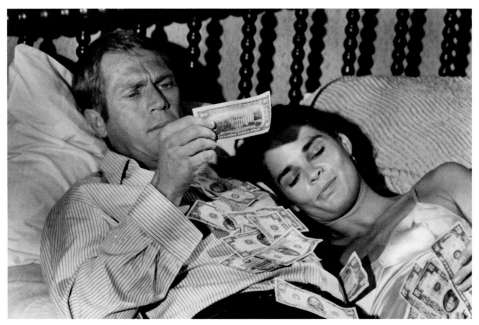

Aries costar chemistry: Steve McQueen and Ali MacGraw in *The Getaway*.

Melanie Griffith takes Jeff Daniels for a ride in *Something Wild*.

SOMETHING WILD
(1986)

Wild thing, you make my heart sing. And in matters of the heart, Mars-ruled lovers can be abrupt, uninhibited, and even a little bit wild, just like Jonathan Demme's edgy '80s rom-com. Free-spirited fireball Melanie Griffith is the titular "something wild" who knocks Jeff Daniels's yuppie socks off when she basically kidnaps him from his executive rut, has her way with him in a motel, and spins his life out of control in her green GTO convertible. Soon, she even has him on the run from the law—and from her psychotic ex (Ray Liotta)—as their road-trip fling escalates into true love. It's a sexy, unpredictable romantic fantasy, right up the Aries alley.

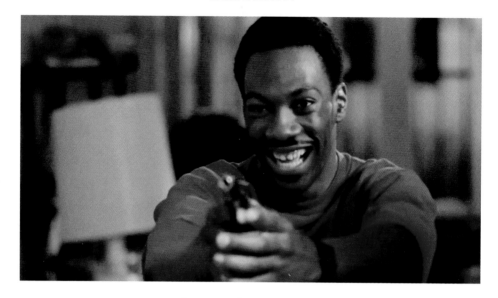

Aries Comedies

BEVERLY HILLS COP
(1984)

Rams stick up for themselves and never stop fighting for what's right. They also have a naughty but playful sense of humor. Aries Eddie Murphy embodies all these qualities in his first solo leading role as streetwise Detroit cop Axel Foley. When his buddy gets killed by drug lords, Axel head-butts his way into the Beverly Hills Police Department, throwing out rules with gleeful abandon and pulling Bugs Bunny–style tricks until he nails the baddies. Shoving bananas into tailpipes, disguising stakeouts as picnics, and luring buttoned-down cops (Judge Reinhold and John Ashton) to a strip club, the prankster prevails where the law fails. Originally intended for Sylvester Stallone, *Beverly Hills Cop* made Murphy a major star when it topped the box office for the year (eventually becoming the highest-grossing comedy in history), and even snared an Oscar nom for Best Original Screenplay.

ABOVE: Aries Eddie Murphy is both tough and funny in *Beverly Hills Cop.*

SNATCH

(2000)

Critic Roger Ebert once described writer/director Guy Ritchie's style as "Tarantino crossed with the Marx Brothers," and *Snatch* delivers exactly that: a gritty crime underworld saturated with nonstop humor. Beneath the banter, brawling, and F-bombs is a clever plot that twists in a million directions—all the better to hold the Aries attention. Brad Pitt steals the show as a hilariously incomprehensible boxer who can't throw a fight if his life depends on it—ideal for tickling the Aries funny bone. Thanks to Ritchie's way with one-liners, the colorful London thugs jump right off the screen as they scramble for an enormous stolen diamond. Rams will enjoy the slapstick brutality, but half the fun for Americans is wading through the Cockney slang to decipher the dialogue. Repeat viewings are a must.

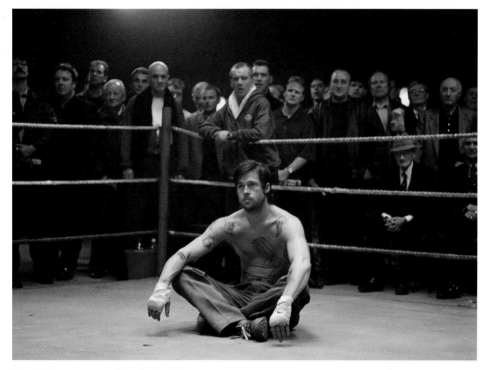

Brad Pitt gets pugnacious in *Snatch*.

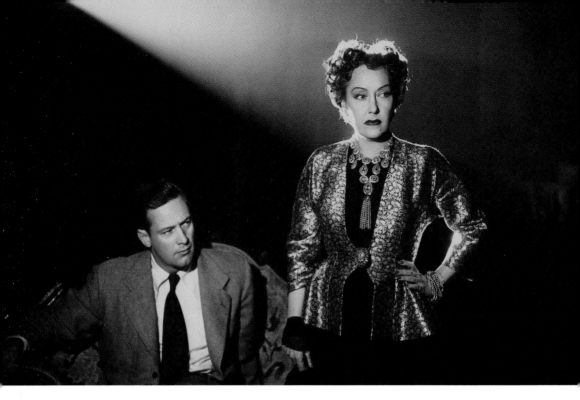

Aries Confrontation Classics

SUNSET BOULEVARD
(1950)

Frustrated Aries male William Holden goes head to head (and horn to horn) with fiery Aries female Gloria Swanson in Billy Wilder's dark, sardonic Hollywood noir—and the sparks fly. When these two egos tango, a washed-up screenwriter meets a dismal fate and an ex–silent screen star is finally, tragically, ready for her close-up. Does anybody really win in the end? And yet, the smoldering of thwarted passions and the scintillatingly witty repartee make it oh-so-much fun while it lasts. Exposing the dark underbelly of fame has never been so funny, nor so desperately sad. "We didn't need dialogue," Swanson boasts as the forgotten Norma Desmond. "We had faces." What an Aries thing to say.

ABOVE: Frustrated Aries passion plays out between William Holden and Gloria Swanson in *Sunset Boulevard*.

WHAT EVER HAPPENED TO BABY JANE?
(1962)

Take the Hollywood Gothic vibe of *Sunset Boulevard*, ramp it up to a ridiculous level, and add two super-divas, Bette Davis and Joan Crawford. What do you get? A one-of-a-kind bitches' brew of macabre camp: the historic screen-pairing of legendary Aries rivals Bette and Joan. Both A-list luminaries from the early 1930s through the 1950s, these headstrong lady rams dissed each other for decades, ever since they competed for the affections of actor Franchot Tone in 1935. Joan got the man, but Bette got the Oscar nod for *Baby Jane*. When they fight it out on film, hair is pulled, faces are slapped, and rats are served for dinner. Hell hath no fury like an Aries scorned.

Continued Viewing for Aries

THE SIGN OF THE RAM (1948)

CHAMPION (1949)

SEVEN SAMURAI (1954)

ARABESQUE (1966)

CARRIE (1976)

DIE HARD (1988)

LA FEMME NIKITA (1990)

POINT BREAK (1991)

PULP FICTION (1994)

RUN LOLA RUN (1999)

FIGHT CLUB (1999)

*KILL BILL VOL. I and
KILL BILL VOL. II* (2003, 2004)

KISS KISS, BANG BANG (2005)

MAD MAX: FURY ROAD (2015)

BABY DRIVER (2017)

PARTNERING UP WITH
ARIES

Wondering what to pick if you're watching with a movie buddy or significant other? Wonder no more!

ARIES AND TAURUS
Raging Bull
(1980)

Martin Scorsese's searing but human drama about the external strength and internal struggles of Italian-American boxer Jake LaMotta will appeal to both rams and bulls.

ARIES AND CANCER
Cool Hand Luke
(1968)

Charismatic convict Paul Newman is tough and sufficiently untamable for Aries viewers, while inciting enough sympathy to melt the sentimental Cancer heart.

ARIES AND GEMINI
The 39 Steps
(1935)

This ahead-of-its-time, super-fast-moving, early Hitchcock spy thriller can hold the attention of Aries and capture the even-shorter attention span of mercurial Gemini.

ARIES AND LEO
La La Land
(2016)

Damien Chazelle's Oscar-winning musical makes a slew of statements about striving for success in Los Angeles, all coated in a snazzy sing-along style. Ambitious Aries and theatrical Leo will love it.

ARIES AND VIRGO
Inception
(2010)

When director Christopher Nolan masterminds an ingeniously clever heist, action-craving Aries and intellectual Virgo are both entertained.

ARIES AND LIBRA
Get Out
(2017)

How do you please aggressive Aries and its polar opposite, passive Libra? With an edge-of-your-seat comedy-horror that skews social-justice fears to the extreme and still manages a triumphant ending.

ARIES AND CAPRICORN
Jerry Maguire
(1996)

Aries and Capricorn share a common trait: They strive to be the best. Rams will respond to the sports element, while cash-conscious Caps love to hear "Show me the money."

ARIES AND SCORPIO
Ruthless People
(1986)

This totally '80s dark comedy mines Reagan-era greed and heartlessness for laughs, its sadistically over-the-top humor striking a comic nerve with rams and scorpions alike.

ARIES AND AQUARIUS
The Martian
(2015)

Combine the powerful Aries survival instinct with some über-smart, Aquarius-level innovation, and you have Matt Damon abandoned on the red planet but determined to thrive.

ARIES AND SAGITTARIUS
The Towering Inferno
(1974)

These two fire signs will sizzle as they watch some of the biggest stars of the 1970s attempt a daring escape from a blazing 138-story skyscraper.

ARIES AND PISCES
Ben-Hur
(1959)

This biblical epic boasts Aries-style action aplenty—including a pulse-pounding chariot race never equaled on film—and extra doses of heart and soul to spark that Pisces empathy.

See also the eleven other "Partnering Up" sections for more sign-compatible recommendations.

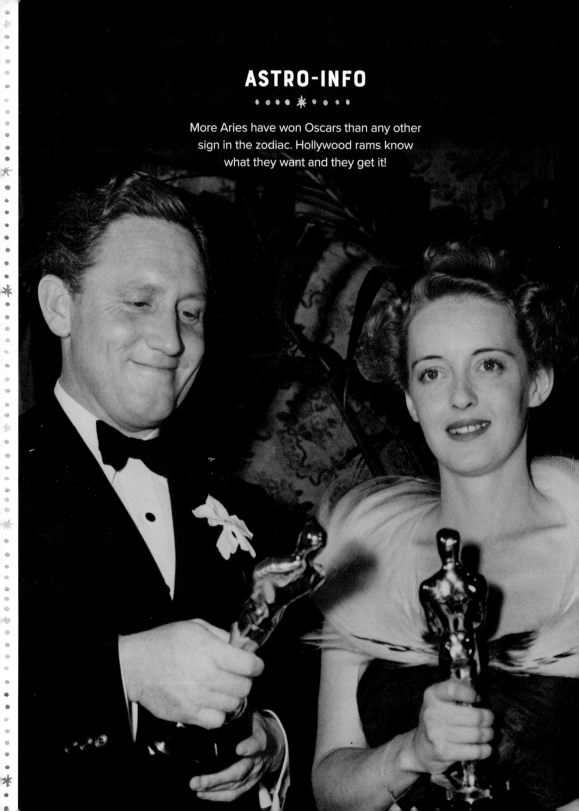

ASTRO-INFO

· · · · ✱ · · · ·

More Aries have won Oscars than any other
sign in the zodiac. Hollywood rams know
what they want and they get it!

ARIES STARS

WARREN BEATTY
(March 30)

KEIRA KNIGHTLEY
(March 26)

MARLON BRANDO
(April 3)

LADY GAGA
(March 28)

CHARLIE CHAPLIN
(April 16)

HEATH LEDGER
(April 4)

JOAN CRAWFORD
(March 23)

STEVE MCQUEEN
(March 24)

RUSSELL CROWE
(April 7)

EDDIE MURPHY
(April 3)

BETTE DAVIS
(April 5)

GREGORY PECK
(April 5)

ROBERT DOWNEY JR.
(April 4)

KRISTEN STEWART
(April 9)

JAMES FRANCO
(April 19)

SPENCER TRACY
(April 5)

JENNIFER GARNER
(April 17)

EMMA WATSON
(April 15)

ALEC GUINNESS
(April 2)

REESE WITHERSPOON
(March 22)

OPPOSITE: Aries stars Spencer Tracy and Bette Davis receive Oscars.

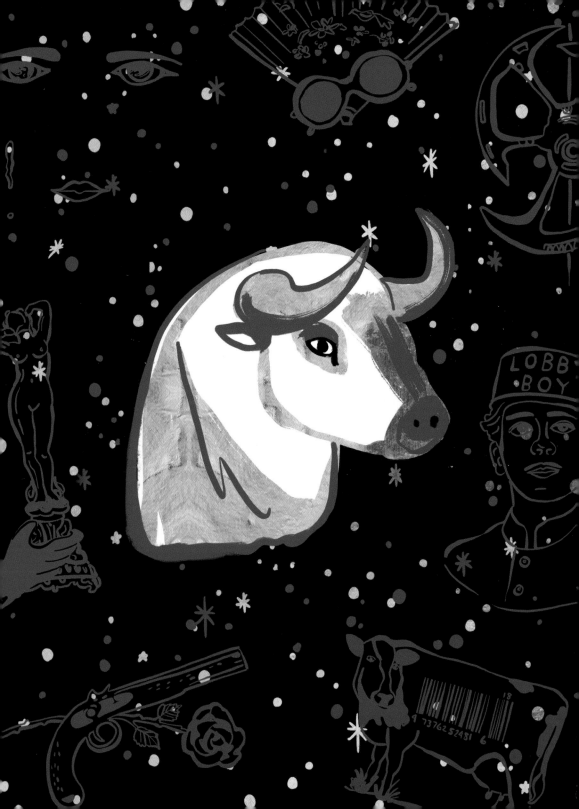

TAURUS

APRIL 21–MAY 21

AN EARTH SIGN RULED BY LOVEY-DOVEY PLANET VENUS, TAURUS the bull gravitates toward beauty, creature comforts, and material wealth. Though romantic and secretly sentimental, the Taurus-born are unwaveringly sturdy (some would say stubborn), dependable, and practical. All the earth signs (Taurus, Virgo, and Capricorn) are into practical concerns—specifically work and paychecks—but for Taurus, a job means one thing: lifestyle security. Bulls work hard during the day so they can enjoy curling up with a good movie, a delicious dinner, and a fine Merlot in the evening. This makes Taurus a fabulous film-watching buddy. Taureans probably not only have the swankiest, most sumptuous sofa and the best TV in the neighborhood, but they won't chatter though the movie (that would be verbose Gemini!). Art, music, and movies are as important to Taureans as food and drink, but they are unlikely to jump on the latest entertainment trends. Instead, they keep a small collection of old, comfortable favorites that they watch and re-watch until they have every line of dialogue memorized.

Taurus, it's no secret that you have a reputation for being, well, not exactly speedy. But only a hater would call you slow. You take your time and do things right, an awesome and increasingly rare quality in this high-speed digital age. You don't mind spending a few hours absorbing a lengthy movie, as long as it has grace, integrity, and enough substance to sink your horns into, like David Lean's slow-simmering epic *Lawrence of*

Nadia Gray revels in the sweet life in *La Dolce Vita*. OPPOSITE: Vivien Leigh as Scarlett O'Hara in *Gone With the Wind*.

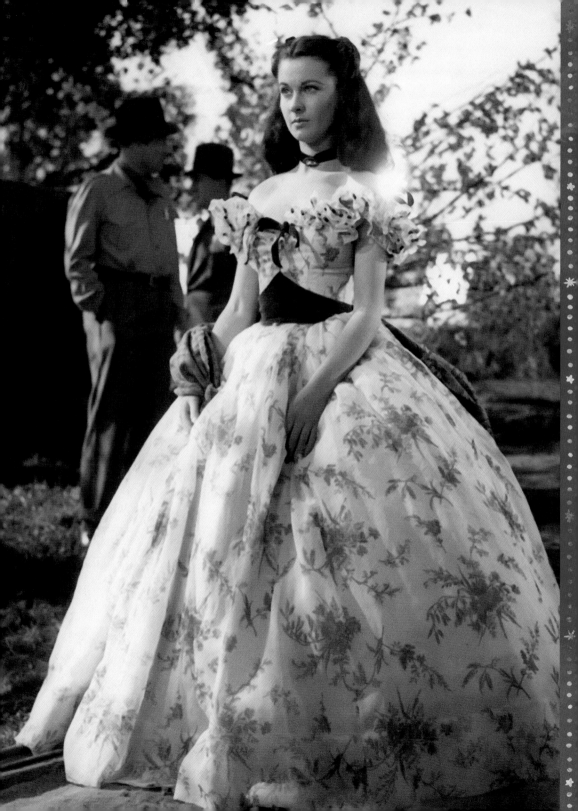

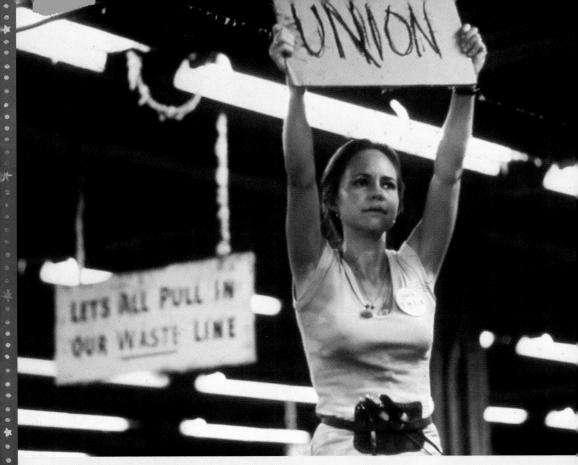

Sally Field is a working-class hero in *Norma Rae*.

Arabia (1962) or the saga *Barry Lyndon* (1975), Stanley Kubrick's opulent three-hour character study of an eighteenth-century opportunist (Ryan O'Neal). *Gone with the Wind* (1939)—with its fundamentally Taurean values regarding the importance of land and property—is an epic that will be (if it already isn't) welcome on your flat-screen.

You bulls are supremely sensual, which is not to say merely sexual. You crave movies that drench your senses in atmosphere, music, costumes, and set design— whether drama, comedy, or romance. Josef von Sternberg's exercise in extravagance, *The Scarlet Empress* (1934); Federico Fellini's *La Dolce Vita* (1960), with its upscale ennui; and the future-fabulous *Passengers* (2014) are a handful of movies that envelop their audience in visual finery. Also appealing to Taurus are the Deco-delightful 1930s musicals starring Fred Astaire and Ginger Rogers.

Though you may indulge in cinematic flights of fancy, elves and hobbits hold little fascination for you, Taurus. You prefer movies grounded in authenticity. Though represented by a bull, you have zero tolerance for bullshit. The story must ring true. Films inspired by real people, such as *Norma Rae* (1979), featuring Sally Field's Oscar-winning turn as a determined blue-collar heroine, and *Serpico* (1973), starring Al Pacino as the only cop in his Manhattan precinct who refuses to turn corrupt, are tried-and-true Taurus classics. Earthy, nature-based documentaries like *Food, Inc.* (2008) and *Bears* (2014) are also up your alley.

Taurus filmmakers tend to capture indelible imagery with their cameras, and to craft films that endure for generations. In addition to the recommendations that follow, take a gander at the work of directors Wes Anderson, James L. Brooks, Jane Campion, Frank Capra, Sofia Coppola, Richard Donner, Amy Heckerling, George Lucas, Satyajit Ray, Lar von Trier, John Waters, Orson Welles, Robert Zemeckis, and Fred Zinnemann, all born under the sign of the bull.

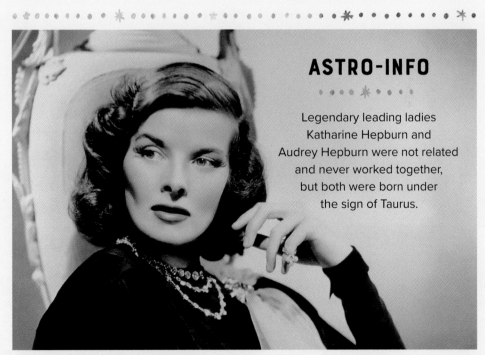

ASTRO-INFO

Legendary leading ladies Katharine Hepburn and Audrey Hepburn were not related and never worked together, but both were born under the sign of Taurus.

Legendary Taurus Katharine Hepburn.

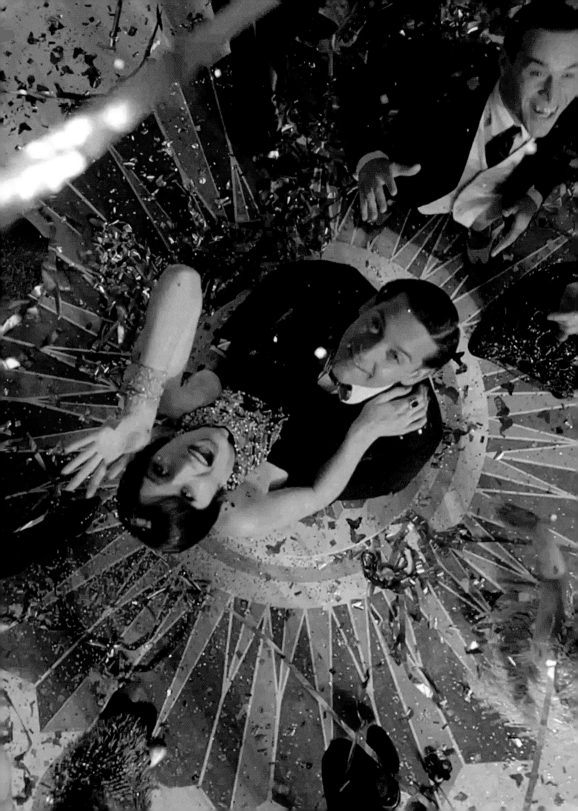

Totally Taurus Flicks

THE GREAT GATSBY
(2013)

Baz Luhrmann's outré spin on F. Scott Fitzgerald's 1925 novel clicks with so many Taurus sensibilities. It's a big-screen explosion of every glitzy, rolling-in-money daydream you've ever had. But it's also an ode to the virtue of patience. Leonardo DiCaprio's Jay Gatsby waits for years, planning, amassing a fortune, and devoting his life to impressing the object of his amour, the fair Daisy (Carey Mulligan), with his flashy material worth. Under Luhrmann's distinctive direction, Roaring '20s fashions intertwine with twenty-first-century hip-hop to form a jazzy pastiche. Beneath all the layers of visual stimulation, the timeless story—with its themes of hope, tragedy, and decadence that could apply to any era—touches that Taurus soft spot.

THE GRAND BUDAPEST HOTEL
(2014)

The Venus-ruled are known for their exquisite taste, and Texas-born auteur Wes Anderson is no exception. With *The Grand Budapest Hotel*, he outdoes himself and serves up what Richard Corliss of *Time* magazine called a "rich torte of a movie" that recounts the experiences of hotel concierge extraordinaire Monsieur Gustave H. (Ralph Fiennes) and his apprentice, lobby boy Zero (Tony Revolori). Set in the fictional Republic of Zubrowka in the 1930s, this polished comedy received Academy Award nominations for its striking production design, soigné costumes, and meticulous direction, among six other categories. It's kitschy and quirky, but with a heart, a sincere point of view, and laugh-out-loud dialogue to boot. Luxury-loving Taurus will feast on this torte, and its promise of (to borrow a quote from Gustave H.) "faint glimmers of civilization" in an uncivilized world.

OPPOSITE: Baz Luhrmann's *The Great Gatsby* depicts Taurean opulence.

Taurus Date Movies

THE AGE OF INNOCENCE
(1993)

Bulls move cautiously in love, just like the couple in Martin Scorsese's aesthetically lush, subtly powerful period romance. Bound by the restrictive guidelines of Victorian-age Manhattan, lawyer Newland Archer and Countess Ellen Olenska (Taurus costars Daniel Day-Lewis and Michelle Pfeiffer) slowly, gently fall in love, but are unable to pursue a relationship that violates the etiquette of their upper-crust 1870s society. As their fable unfurls like a flower, Taurus will respond to the ever-intensifying levels of restrained passion (but no fast moves) and the sturdy moral cores that shine through in Newland and Ellen's characters. Gorgeously shot by Michael Ballhaus, splendidly costumed by Gabriella Pescucci (who won an Oscar for her work), and based on the Pulitzer Prize–winning novel by Edith Wharton, *The Age of Innocence* will tame your favorite wild bull.

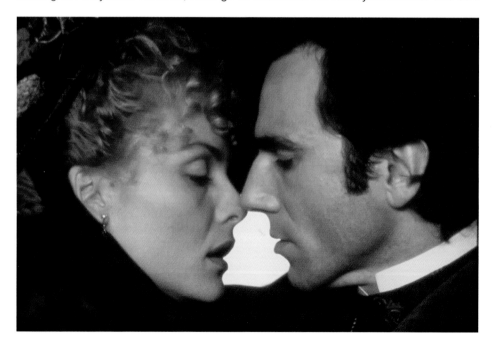

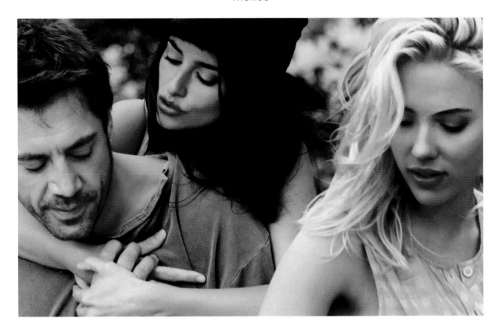

VICKY CRISTINA BARCELONA

(2008)

For your next date night, Taurus, immerse yourself in the sultry strains of Spanish guitar, great art, red wine, and balmy summer evenings in Barcelona with American tourists Vicky (Rebecca Hall) and Cristina (Scarlett Johansson). Both girls are attracted to the seductive Juan Antonio (Javier Bardem), but Woody Allen's light, lusty romantic adventure turns dark when Spanish megastar (and Taurus beauty) Penelope Cruz appears as Juan Antonio's temperamental artist ex-wife, Maria Elena. As an atmospheric character study, *Vicky Cristina Barcelona* intrigues, but has an unsettled, unfinished quality, like one of Maria Elena's abstract paintings. Yet it's as soft as a June breeze in Spain. Best paired with tapas.

ABOVE: Javier Bardem, Penelope Cruz, and Scarlett Johansson make a sultry Spanish threesome in *Vicky Cristina Barcelona*. OPPOSITE: Taurus costars Michelle Pfeiffer and Daniel Day-Lewis in *The Age of Innocence*.

Taurus Comedies

CRAZY RICH ASIANS
(2018)

"So your family is, like, rich?" Rachel (Constance Wu) asks her boyfriend, Nick (Henry Golding), when he books them a sumptuous first-class suite on their flight to Singapore. When Nick admits they are "comfortable," Rachel gets the message. "That's exactly what a super-rich person would say." So kicks off this comical ode to excess from director John M. Chu. As the title implies, Nick's Chinese family is not just rich, but *crazy* rich—palatial-estate-with-its-own-zip-code rich. The film has fun with shopping sprees and decadent dinners, yet is also grounded in authentic emotions. The very Taurean moral of the story is that integrity is more important than money . . . but if you've got the cash, flaunt it! Come for the bling, stay for the Cantonese-language version of "Material Girl."

A NEW LEAF
(1971)

This half-forgotten '70s gem from Taurus writer/director/actress Elaine May has oodles of clumsy, cynical charm, and a dual theme of plants and money—both of which tend to pique the Taurus interest. May is Henrietta, a socially awkward but filthy-rich botanist whose one dream in life is to discover a new species of fern. When gold-digging grump Henry (the hilariously deadpan Walter Matthau) blows through his fortune, he marries Henrietta so he can poison her and inherit her wealth. "I don't want to share things!" he grumbles. "I want to own them all by myself." Henry and Henrietta's rustic camping trip to the Adirondacks takes a surprisingly tender turn just as he's about to bump her off. Ah, the wonders of love.

OPPOSITE: Elaine May, a Taurus, directs *A New Leaf.*

Dependable Taurus Classics

HIGH NOON
(1952)

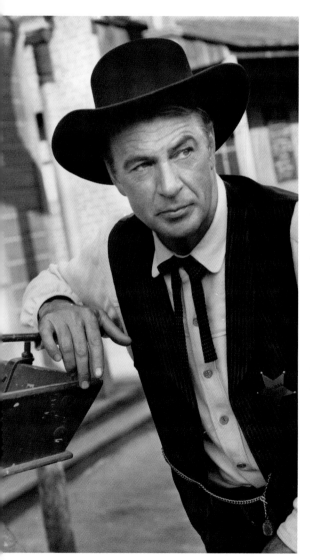

That famous Taurus stubbornness is essentially just a refusal to cave, a determination to stand strong in the face of all opposition and not budge—especially when you know what you're doing is right. Taurean superstar Gary Cooper exemplifies this trait in spades in the classic Western *High Noon*, Fred Zinnemann's timeless tale of a small-town marshal who must fight the townsfolk's apathy, the admonishments of his new Quaker wife (Grace Kelly in her first major movie role), and his own fears as he faces off against four deadly outlaws at once . . . all by his lonesome. Some consider the film an allegory for McCarthyism in Hollywood, but, seen through the lens of astrology, it's a pure paean to the admirably obstinate bull.

Gary Cooper embodies Taurus ideals in *High Noon*. OPPOSITE: Peter O'Toole and Taurus star Audrey Hepburn in *How to Steal a Million*.

36

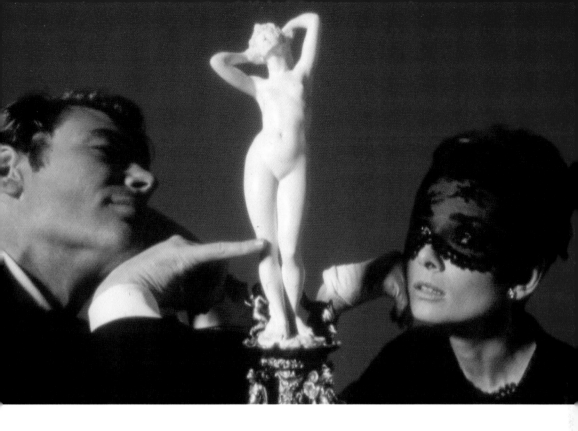

HOW TO STEAL A MILLION
(1966)

The world of forged fine art sets the stage for William Wyler's adventure-romance-crime comedy, starring renowned Taurus glamour girl Audrey Hepburn. As both a stellar actress and a style icon, Audrey made some unforgettable films (especially her Oscar-awarded Hollywood debut in *Roman Holiday* [1953] and the ever-winsome *Breakfast at Tiffany's* [1961]), but *How to Steal a Million* is a slightly lesser-known treasure in her filmography. Draped in a smart Givenchy wardrobe, Hepburn's Nicole teams up with burglary expert Simon (a supremely suave Peter O'Toole) to swipe a million-dollar statue from a Paris museum. Shot on location in the City of Lights, this caper was produced during the last hurrah of the big-budget Hollywood studio system, when no expense was spared. It's sweet, sophisticated, witty, and takes the time to savor its eye-dazzling surroundings—which is so Taurus.

Continued Viewing for Taurus

THE PHILADELPHIA STORY (1940)

THE SUN ALSO RISES (1957)

BREAKFAST AT TIFFANY'S (1961)

8 1/2 (1963)

THE GARDEN OF THE FINZI-CONTINIS (1970)

BEING THERE (1979)

ARTHUR (1981)

COUNTRY (1984)

PRETTY WOMAN (1990)

ENCHANTED APRIL (1991)

THE PIANO (1993)

CHOCOLAT (2000)

BRIDGET JONES'S DIARY (2001)

THE MATADOR (2005)

MARIE ANTOINETTE (2007)

⤳ TAURUS HIDDEN GEM ⤳

Want to sneak a peek at celebrated Taurus actor Daniel Day-Lewis before he became a household name? Watch *My Beautiful Laundrette* (1985), Stephen Frears's offbeat comedy-drama of forbidden romance and reno-vated London laundromats. Day-Lewis's performance as the protagonist's punkish boyfriend put him on the map at age twenty-eight.

PARTNERING UP WITH
TAURUS

*Wondering what to pick if you're watching with a movie buddy or significant other?
Wonder no more!*

TAURUS AND ARIES
Out of Sight
(1998)

Tough-as-steel US Marshal Jennifer Lopez meets her match in cool career criminal George Clooney in this stylin' crime romp from Steven Soderbergh. A perfect earth-meets-fire flick.

TAURUS AND CANCER
Diner
(1982)

Since Taurus and Cancer are bona-fide foodies, Barry Levinson's wistful, humorous ode to a small-town diner and the guys who hang out there will nourish the souls of both. Pass the ketchup.

TAURUS AND GEMINI
Sleuth
(1972)

The takes-its-sweet-time pace and visual trickery of this murderously clever cat-and-mouse game will delight bulls; twins will appreciate the mental hopscotch required to keep up.

TAURUS AND LEO
The King's Speech
(2010)

This carefully honed drama with Colin Firth and Geoffrey Rush is about maintaining dignity in the public eye—a very Leo concern—and about the hard work (Taurus) behind the royal image.

TAURUS AND VIRGO
Land Ho!
(2014)

Two retired ex–brothers-in-law trek across Iceland in this outdoorsy, indie comedy. Taurus and its earth-bound cousin Virgo will revel in the picturesque scenery.

TAURUS AND LIBRA
Fantastic Mr. Fox
(2009)

Farm life has never been so stylish, nor talking-animal movies quite as sophisticated as Wes Anderson's animated ode to a family of foxes. Required viewing for grounded Taurus and fanciful Libra.

TAURUS AND CAPRICORN
Something Ventured
(2011)

Money-minded Taurus and Cap will be fascinated by this documentary about venture capitalism, and the businessmen who backed some truly revolutionary companies.

TAURUS AND SCORPIO
Dangerous Liaisons
(1988)

The luxe setting of eighteenth-century Paris may appear genteel (for Taurus), but beneath the surface seethes a hotbed of malice and manipulation (are you listening, Scorpio?) in this Oscar-winner.

TAURUS AND AQUARIUS
Far from the Madding Crowd
(1967)

John Schlesinger's seductive, pastoral, and earthy adaptation of Thomas Hardy's 1874 novel stars Julie Christie as Bathsheba, an independent woman eons ahead of her time.

TAURUS AND SAGITTARIUS
Topkapi
(1964)

This classic heist film unites Maximilian Schell and Melina Mercouri as two high-rent thieves living it up in Istanbul. Bulls and archers alike will groove to this glorious Technicolor travelogue.

TAURUS AND PISCES
Immortal Beloved
(1994)

The haunting story of Ludwig van Beethoven (Gary Oldman) and the women in his life is romantic enough for fish to fancy, gilt-edged enough to impress the discerning bull.

See also the eleven other "Partnering Up" sections for more sign-compatible recommendations.

TAURUS STARS

FRED ASTAIRE
(May 10)

KATHARINE HEPBURN
(May 12)

CATE BLANCHETT
(May 14)

DWAYNE JOHNSON
(May 2)

PIERCE BROSNAN
(May 16)

JESSICA LANGE
(April 20)

CHER
(May 20)

JACK NICHOLSON
(April 22)

GEORGE CLOONEY
(May 6)

AL PACINO
(April 25)

GARY COOPER
(May 7)

MICHELLE PFEIFFER
(April 29)

PENELOPE CRUZ
(April 28)

JAMES STEWART
(May 20)

DANIEL DAY-LEWIS
(April 29)

BARBRA STREISAND
(April 24)

GAL GADOT
(April 30)

UMA THURMAN
(April 29)

AUDREY HEPBURN
(May 4)

RENÉE ZELLWEGER
(April 25)

GEMINI

MAY 22-JUNE 21

LIKE TWO PEOPLE TRAPPED IN THE BODY OF ONE, THOSE BORN under the air sign of Gemini the twins have more energy—mental and physical—than they know what to do with. Voted most likely to move in a billion different directions at once, Geminis can change their minds on a dime, multitask like nobody's business, and manage to be charming even as they talk over the dialogue in a movie (they really can't help it). Because Mercury, the fastest-moving planet in the solar system, governs their personalities, twins are never boring. In fact, they usually bring the party wherever they go. The problem is keeping up with them! The greatest gift Geminis give, however, is not their lively spirit or contagious energy, but their ability to talk things out. If you're in

Sean Connery (with Shirley Eaton) as secret agent James Bond in *Goldfinger*.

Naomi Watts and Laura Elena Harring in *Mulholland Drive*.

a pickle, they'll stay on the phone for hours until your troubles are thoroughly resolved. Whether it's talking, writing, singing, songwriting, or penning poetry, twin guys and gals lend a flash of creative genius to everything they touch.

Mercury, the mythological messenger of the gods, is the grand communicator and playful trickster of the planets. If you're a Gemini, your ideal entertainment involves choice words, wordplay, bubbly banter, and laughter. You'll rarely be down for a brooding, weighty film, but you make a willing accomplice for any light-as-air comic caper. Zany, chaotic laugh-fests such as *Bringing Up Baby* (1938), *The Great Race* (1965), and *Airplane!* (1980) can always elicit at least a chuckle or two from you.

Above and beyond comedies, Gemini, your quicksilver mind can handle a movie that requires intense thinking (as long as it's not too slow-paced) and you possess a high tolerance for plots that others find confusing. Somehow, you always catch on. Tricky cin-

ematic puzzles like *Jacob's Ladder* (1990), *Mulholland Drive* (2001), and *Shutter Island* (2010) give that Gemini gray matter a welcome workout. Because you're an expert in the art of conversation, you may also enjoy movies in the vein of *Coffee and Cigarettes* (2003) and *Before Midnight* (2013), in which the gift of gab takes center stage.

Twins are sometimes accused of having a dual nature or "split personality." Let's face it, Gemini—this means you've got what it takes to be a double agent! With your ability to juggle at least two identities, you're the perfect audience for spy movies. When it comes to espionage, it doesn't get more iconic than James Bond in *Goldfinger* (1964), the gold standard of the Sean Connery–era Bond films. For a more contemporary 007 experience, check out Daniel Craig rivaling Connery at his best in *Casino Royale* (2006). Kevin Costner in *No Way Out* (1987), Denzel Washington and Ryan Reynolds in *Safe House* (2012), and Gemini comic Mike Myers's definitive spoof on the spy genre, *Austin Powers: International Man of Mystery* (1997), also feed your need for secret-identity fare.

In the field of filmmaking, Gemini directors tend to have endless youth—often working into their golden years—and excel at making high-energy films with quotable dialogue. In addition to the recommendations that follow, observe the films of Clint Eastwood, Lasse Hallstrom, Howard Hawks, James Ivory, Angelina Jolie, Jay Roach, Robert Rodriguez, Agnès Varda, and Josef von Sternberg to see how that Gemini energy translates to the medium of movies.

ASTRO-INFO

With his awe-inspiring powers of deductive reasoning, amateur sleuth Sherlock Holmes is a cultural icon, and the most portrayed literary character in history (according to *Guinness World Records*), having appeared in over 250 movies. Sir Arthur Conan Doyle, the creator of Holmes, was a Gemini with a razor-sharp mind and a way with words.

OPPOSITE: Cary Grant and Katharine Hepburn in the zany comedy *Bringing Up Baby*.

46

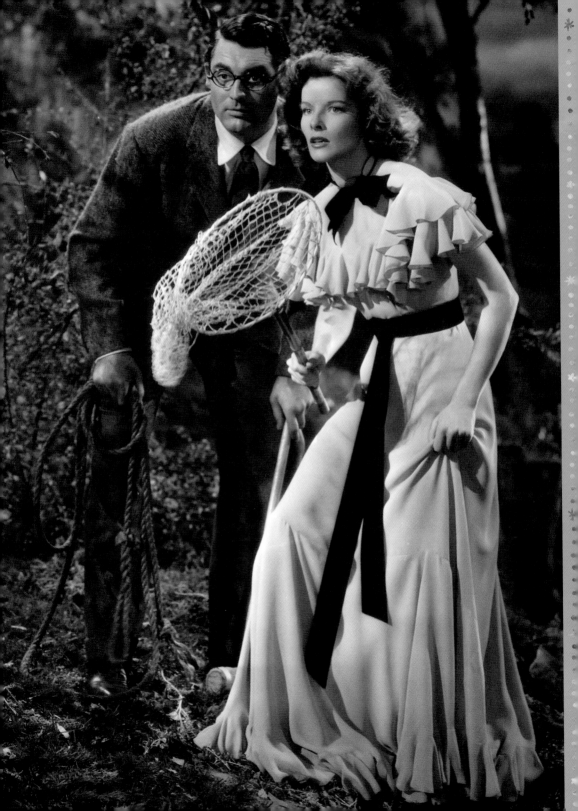

Gemini Gems

MEMENTO
(2000)

Alternating between black-and-white and color, between objective and subjective reali-ties, Christopher Nolan's second film is a mind-bending neo-noir about a man (Leonard, played by Guy Pearce) who must track down his wife's killer without the aid of his short-term memory. Brilliantly crafted using a time line that blends both reverse and forward chronology, *Memento* is a taut exercise in mental agility worthy of the sharpest Gemini. Follow Leonard as he pieces together clues—which he records in notes, photos, and even tattoos—but also follow the story as it twists and zigzags, and characters' true motives are revealed. With great supporting performances from Carrie-Ann Moss and Joe Pantoliano, this thriller manages to be smart, tense, and darkly funny. Repeat view-ings recommended.

CATCH ME IF YOU CAN
(2002)

Twins are nothing if not clever. And, as air signs, they're fond of flying. If anyone can appreciate the special set of talents required to impersonate a commercial airline pilot (and fly anywhere for free), a government agent, a doctor, and five other identities before one's twenty-first birthday, it's a Gemini. In Steven Spielberg's intense-yet-wink-ing biopic, Leonardo DiCaprio embodies the real-life impostor Frank Abagnale, with Tom Hanks hot on his heels as the FBI agent who finally catches him. Trotting across the globe in the swinging '60s, living the high life on forged checks and false identities, Frank gets away with his *vida loca*—for a while. After he's captured, his in-demand forg-ery abilities might just snag him yet another new identity.

OPPOSITE: Leonardo DiCaprio lives the Gemini dream in *Catch Me If You Can.*

Gemini Date Movies

MOULIN ROUGE!
(2001)

Q: What has the outrageous humor of a retro cartoon; the frantic, sexy vibe of a music video; and the surreal quality of a fever dream? A: Baz Luhrmann's one-of-a-kind musical romance, *Moulin Rouge!* Set in the famed Paris nightclub at the turn of the twentieth century, this giddy whirlwind of a movie is crammed with nonstop activity: talking, singing, dancing, writing, and falling in love all seem to be happening simultaneously for the full two hours and ten minutes. (You don't have to be a Gem to keep up, but it helps.) Gemini leading lady Nicole Kidman ascended to megastar status (and earned her first Oscar nomination) for her glittering portrayal of mercurial courtesan Satine, the object of Christian's (Ewan McGregor) undying love. Put on the rhinestones and red lipstick for this one.

Gemini Nicole Kidman as the mercurial Satine in *Moulin Rouge!* OPPOSITE: Jim Carrey and Kate Winslet in *Eternal Sunshine of the Spotless Mind.*

ETERNAL SUNSHINE OF THE SPOTLESS MIND
(2004)

Talk about living inside your own head, Gemini. Most of the action in *Eternal Sunshine of the Spotless Mind* takes place inside the heads of ex-lovebirds Joel and Clementine (Jim Carrey and Kate Winslet), who undergo procedures to erase all memories of their relationship from their brains. In order to rekindle their affair, this star-crossed couple must retrace their love through the byzantine circuits of the mind. With an insightful, Oscar-winning script by Charlie Kaufman and unconventional direction by Michel Gondry, *Eternal Sunshine* is by turns wacky, whimsical, and truly heartbreaking; its tonal shifts are all over the map. You and your twin soul will fall head over heels all over again as you watch this cerebral journey that celebrates the power of love—in all its improbable, imperfect glory.

Gemini Comedies

SOME LIKE IT HOT
(1959)

Bogus identities, gender-swapping, and all kinds of good-natured Gemini deception are afoot in the classic laugh-riot *Some Like It Hot*. As Tony Curtis (a Gemini) and Jack Lemmon pose as women to escape murderous mobsters, Tony also poses as a wealthy heir to nab sexy Marilyn Monroe (another Gemini), who is posing as a debutante to impress Tony's fake millionaire. Got that? No? It doesn't matter, because comic genius cowriter/director Billy Wilder (born June 22, on the cusp of Gemini and Cancer) fashions the wittiest wordplay, the most frenetic situations, and the most hysterical dialogue in this unforgettable gender-bender that was voted the funniest comedy movie ever made by the American Film Institute in 2000, and the best-ever big-screen comedy by the BBC in 2017. A must-see for the Mercury-ruled.

SPY
(2015)

A contemporary twist on espionage spoofs, writer/director Paul Feig's *Spy* stars Melissa McCarthy as Susan Cooper, an average woman who works behind the scenes at the CIA—and just happens to be trained as a super-badass spy, too. Comically self-deprecating but with a feisty streak you don't wanna mess with, Susan gets to display her wicked skills when dreamy Agent Fine (Jude Law) is brought down in the line of duty and she's tapped to take over. Featuring multiple assumed identities, double agents galore, and a fast-paced, laugh-filled story, *Spy* will tickle the Gemini funny bone. Plus, unlike many a CIA tale, it boasts a theme of female empowerment and some truly amusing ladies: Rose Byrne, Miranda Hart, and Allison Janney also star.

OPPOSITE: Jack Lemmon and Tony Curtis forge new identities in *Some Like It Hot*.

Gemini Double-Trouble Classics

THE DARK MIRROR
(1946)

"Twins!" proclaims the poster for this nifty noir. "One who loves . . . and one who loves *to kill*!" With the adroit Olivia de Havilland embodying both twins—evil Terry and docile Ruth—*The Dark Mirror* is a fascinating exploration of duality that set the standard for the oft-emulated "good twin–bad twin" story line (see *Sisters* [1972] and *Dead Ringers* [1988], among others). Though the movie's dubious science—courtesy of a psychiatrist played by Lew Ayres—doesn't hold up to scrutiny today, de Havilland's dual performance still entices, the double-exposure effects are seamless, and it's impossible not to get engrossed in the edge-of-your-seat-suspenseful plot. Especially if your sign is Gemini.

Olivia de Havilland plays twins in *The Dark Mirror*. OPPOSITE: Gemini bombshells Marilyn Monroe and Jane Russell rehearse a song for *Gentlemen Prefer Blondes*.

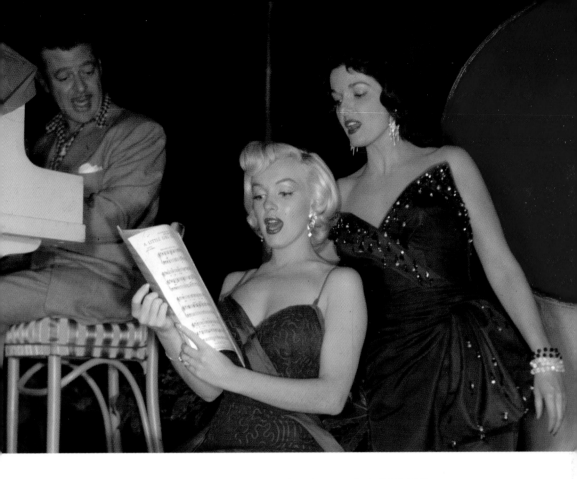

GENTLEMEN PREFER BLONDES

(1953)

Gemini filmmaker Howard Hawks directs two Gemini bombshells, blonde Marilyn Monroe and brunette Jane Russell, in this sparkling musical. The die-hard gal-pals represent opposite ends of the spectrum: breathy, soft Lorelei (Marilyn) and brash, outspoken Dorothy (Jane), two personalities as different as night and day. Replete with drop-dead gorgeous gowns and sets, sing-along numbers ("Diamonds Are a Girl's Best Friend," anyone?), and droll dialogue by acclaimed wit Anita Loos, this double-dose of curvaceous coquettes received mixed reviews on its 1953 release, but has since become an undisputed classic. The reason? Timeless performances by Monroe and Russell. There's nothin' like a Gemini dame . . . or two.

Continued Viewing for Gemini

DR. JEKYLL AND MR. HYDE (1931)

MY MAN GODFREY (1936)

WHAT A WAY TO GO! (1964)

WHAT'S UP, DOC? (1972)

THE SECRET OF MY SUCCESS (1987)

FACE/OFF (1997)

THE MAN WHO KNEW TOO LITTLE (1997)

SLIDING DOORS (1998)

ADAPTATION (2002)

THE PRESTIGE (2006)

FLASH OF GENIUS (2008)

IN BRUGES (2008)

ENEMY (2013)

SPLIT (2016)

GEMINI (2018)

⇒ GEMINI HIDDEN GEM ⇐

Although Gemini star Morgan Freeman has been acting professionally since the early 1970s, he didn't receive mainstream attention until his breakout role as a pimp named Fast Black in the 1987 movie *Street Smart*. Also starring Christopher Reeve and Kathy Baker, this overlooked crime thriller is worth seeking out for its performances alone.

Morgan Freeman in the 1987 film *Street Smart*.

PARTNERING UP WITH
GEMINI

Wondering what to pick if you're watching with a movie buddy or significant other? Wonder no more!

GEMINI AND ARIES
True Lies
(1994)

James Cameron's action-comedy block-buster is packed with hair-raising stunts (for Aries) and secret-identity intrigue (for Gems), plus an award-winning perfor-mance by Jamie Lee Curtis.

GEMINI AND CANCER
The Help
(2011)

Gemini actress Octavia Spencer won an Oscar for her breakthrough role as a defiant maid in this Cancerian domestic drama, set in the Deep South when seg-regation was the law of the land.

GEMINI AND TAURUS
Midnight Run
(1988)

Robert De Niro's bounty hunter and Charles Grodin's white-collar criminal start out with little to say, then end up "shooting the bull" via improvisational dialogue in this buddy comedy.

GEMINI AND LEO
Tootsie
(1982)

Leo Dustin Hoffman shines as an actor who poses as a no-nonsense lady to win a role on a soap opera. Laughter (and great dialogue) ensues: "I was a better man with you as a woman than I ever was with a woman as a man." Geminis will get it.

GEMINI AND VIRGO
A Room with a View
(1985)

Gemini filmmaker James Ivory directs Gemini actress Helena Bonham Carter in this elegant adaptation of a subtly satirical 1908 E. M. Forster novel.

GEMINI AND LIBRA
Spotlight
(2015)

A disparate group of investigative reporters exposes an ongoing epidemic of child abuse in the Catholic Church. A true story about the power of words (Gemini) and teamwork (Libra).

GEMINI AND CAPRICORN
His Girl Friday
(1940)

The multifaceted Howard Hawks was at his most Gemini-ish when he made this rapid-fire comedy, with dialogue spoken at 240 words per minute. And a workplace romance to make Capricorn happy.

GEMINI AND SCORPIO
Sin City
(2005)

Gemini director Robert Rodriguez and comic-book artist Frank Miller immerse themselves in the deep, dark city, and the result is a slick anthology with an impressive ensemble cast.

GEMINI AND AQUARIUS
Moon
(2009)

Both of these air signs are fascinated by space travel. Taking inspiration from 2001: A Space Odyssey *(1968) and* Solaris *(1972) without sacrificing originality,* Moon *is a cerebral rocket ride to the dark side.*

GEMINI AND SAGITTARIUS
I Heart Huckabees
(2004)

David O. Russell's quirky metaphysical comedy clicks with Gemini's need for mental hijinks, and with Sagittarius's spiritual slant.

GEMINI AND PISCES
Do the Right Thing
(1989)

One of Pisces filmmaker Spike Lee's most engaging films, this urban social commentary earns props for memorable characters, witty screenwriting, and a solid core of empathy.

See also the eleven other "Partnering Up" sections for more sign-compatible recommendations.

GEMINI STARS

ANNETTE BENING
(May 29)

NICOLE KIDMAN
(June 20)

HELENA BONHAM CARTER
(May 26)

IAN MCKELLEN
(May 25)

TONY CURTIS
(June 3)

MARILYN MONROE
(June 1)

JOHNNY DEPP
(June 9)

LIAM NEESON
(June 7)

COLIN FARRELL
(May 31)

LAURENCE OLIVIER
(May 22)

MICHAEL J. FOX
(June 9)

NATALIE PORTMAN
(June 9)

MORGAN FREEMAN
(June 1)

ROSALIND RUSSELL
(June 4)

JUDY GARLAND
(June 10)

OCTAVIA SPENCER
(May 25)

NEIL PATRICK HARRIS
(June 15)

MARK WAHLBERG
(June 5)

ANGELINA JOLIE
(June 4)

JOHN WAYNE
(May 26)

CANCER

JUNE 22-JULY 22

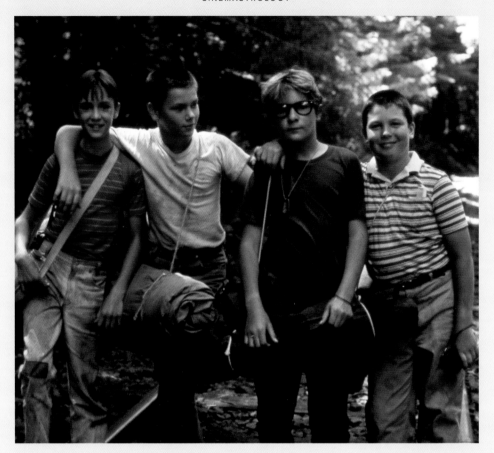

RULED BY THE MYSTERIOUS, EVER-CHANGING MOON, CANCERS—
like the crab that is their symbol—are soft, vulnerable creatures inside a tough, tena-
cious exterior. Just as crustaceans carry their shell (their home) around on their backs,
home and family are everything to this water sign. Whether male or female—or whether
they become parents or not—crabs are maternal and protective toward those they care
about, as the state of motherhood is associated with Cancer. These moody moonchil-
dren, born in the wake of the summer solstice, cling to feelings, childhood memories,
and nostalgia; they harbor a deep well of emotions that they frequently channel into act-

ABOVE: Wil Wheaton, River Phoenix, Corey Feldman, and Jerry O'Connell in *Stand By Me*.
OPPOSITE: Mia Farrow takes her maternal instinct to the extreme in *Rosemary's Baby*.

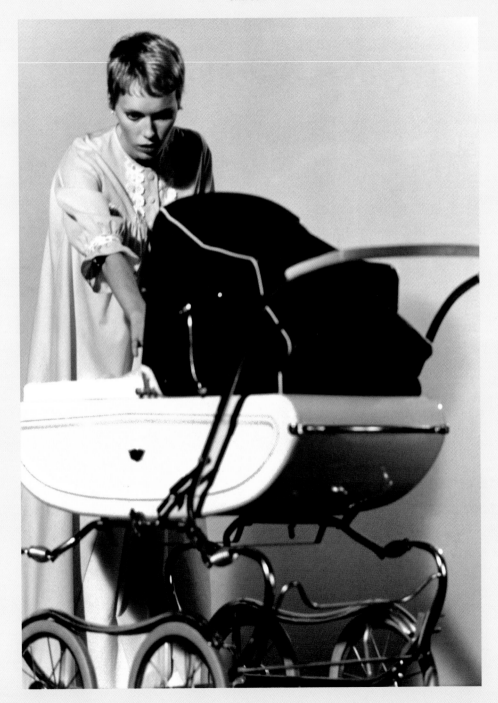

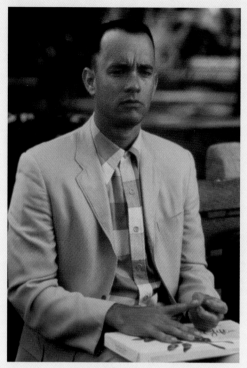

Cancer star Tom Hanks in *Forrest Gump*.

ing, art, or music. They can be shy and naive (think Cancerian Leslie Caron in *Lili* [1953]), or can leap from their shells to become powerhouse bosses like Cancer-born Sylvester Stallone. Like Taurus, Cancer loves to snuggle up and re-watch old favorite flicks while nibbling on a satisfying snack. If you invite a moonchild over for a movie or out to the theater, don't forget the popcorn and candy. Food is an essential part of their entertainment experience.

If you're a Cancer, wistful, inspiring movies, such as Frank Darabont's 1950s-set *The Majestic* (2001), provide nourishment for your soul, as do emotional but uplifting period dramas like *The Color Purple* (1985) and *Glory* (1989). Lunar babies love sentimental stories that bask in the wonder of childhood, like *E.T. the Extra-Terrestrial* (1982), *Fanny and Alexander* (1982), *Boyhood* (2014), or even *Moonlight* (2016), a heartrending yet hopeful tale of a wayward childhood. But moody Cancer isn't always in the mood for tearjerkers. When you need a cinematic hug, movies about grown-up kids-at-heart—think Tim Burton's playful *Pee-Wee's Big Adventure* (1985) and Penny Marshall's bittersweet charmer *Big* (1988)—fill the crabbiest crab with joy.

Cancer, your zodiac sign is the most likely to own a VCR and a collection of VHS tapes. Even if you don't go that far, you likely adore old-school, vintage throwbacks that revel in a simpler time period: *Grease* (1978), *Stand by Me* (1986), and *Cinema Paradiso* (1988), to name a few. You may even dip into the distant past with films like the homey *Little Women* (1994) and the nineteenth-century domestic dramedy *Pride & Prejudice* (2005), or enjoy escaping into a far-flung fairy-tale land, like the one in Rob Reiner's utterly perfect *The Princess Bride* (1987).

Hollywood has a history of mother issues, and this falls right into Cancer's domain. If you're searching for some mama drama, *Applause* (1929), *Mildred Pierce* (1945), *I'll Cry Tomorrow* (1955), *Imitation of Life* (1959), *Rosemary's Baby* (1968), *Mommie Dearest* (1981), *Sophie's Choice* (1982), *Serial Mom* (1994), *Volver* (2006), *Mother!* (2017), and *Ma* (2019) illustrate some of the movies' more twisted maternal fixations.

When it comes to filmmakers, Cancers are ultra-deep, highly imaginative, and excel at capturing the complexities of the human experience with pathos and humor. In addition to the recommendations that follow, you may want to visit the work of Cancerian directors J. J. Abrams, Paul Thomas Anderson, Ingmar Bergman, Mel Brooks, Stephen Chow, Cameron Crowe, George Cukor, Vittorio De Sica, Bob Fosse, Barbara Loden, Sydney Pollack, Lana Wachowski, Joss Whedon, and Billy Wilder.

ASTRO-INFO

Often lauded as one of the greatest actresses of her era, Meryl Streep is a Cancer born right on the cusp (June 22), giving her some Gemini traits as well. Many astrologers credit Meryl's talent to her combination of Cancer sensitivity and Gemini versatility.

Meryl Streep in *Sophie's Choice*.

Cancer Comfort-fests

ALMOST FAMOUS
(2000)

Cancer auteur Cameron Crowe has written and/or directed quite a few personal movies inspired by his own youth (among them *Fast Times at Ridgemont High* [1982] and *Say Anything* [1989]), but *Almost Famous* may be his most autobiographical offering. A direct nod to Crowe's years as a teenage reporter for *Rolling Stone* magazine, this music-obsessed dramedy follows William (Patrick Fugit), a young journalist coming of age in the wild world of 1970s rock. Though the movie is steeped in sex, drugs, and rock 'n' roll, a Cancerian sweetness suffuses the tale, which could have taken on a sordid tone in less expert hands. Moonchildren will appreciate William's deep connection to his hyperprotective mom (Frances McDormand), his heartfelt regard for a sensitive groupie (Kate Hudson), and the essential innocence he tries to hide behind a cool façade.

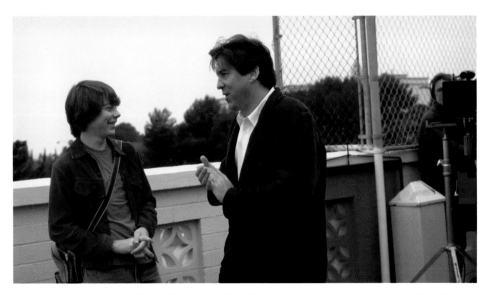

Cancer Cameron Crowe directs Patrick Fugit in *Almost Famous*. OPPOSITE: In *The Royal Tenenbaums*, family takes center stage.

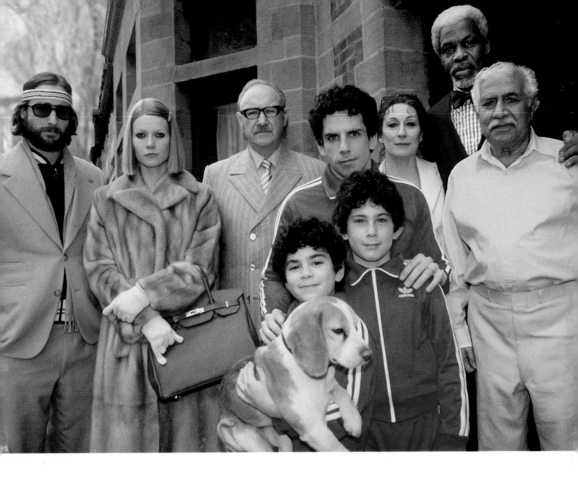

THE ROYAL TENENBAUMS
(2001)

Crabs often scuttle for the safety of their childhood homes when they hit hard times. In Wes Anderson's *The Royal Tenenbaums*, disillusioned siblings Chas (Ben Stiller), Margot (Gwyneth Paltrow), and Richie (Luke Wilson) return home to the comfort of their mom (Angelica Huston) when they fear their estranged father (Gene Hackman) is dying. With irreverence and wit, Anderson examines dysfunction in a creatively gifted family, and how the Tenenbaums reconnect with each other in a crisis. It's rare that a film captures the particular melancholy Cancers can feel when their youthful dreams don't come to fruition; this one is all about it. "I think of humor as also being a little bit sad," cowriter Owen Wilson has said, and that sentiment sets the tone for this surreal family fable.

Cancer Date Movies

MOONSTRUCK

(1987)

Lunar lads and lasses are hopeless romantics at any age. At forty, Loretta Castorini (Cher) is struck by an unexpected romance with her fiancé's brother (Nicolas Cage) when a supermoon illuminates the sky over Brooklyn. Cher won on Oscar for her portrayal in Norman Jewison's operatic comedy, a movie that paints the members of Loretta's close-knit Italian-American family so vividly, we feel we know them. Especially her aging mother (Olympia Dukakis) and father (Vincent Gardenia), who rekindle their love in the film's final scene. "I need my family around me now," Loretta tells her suitors when they ask to speak to her alone. A modern-day fairy tale about the transformative power of love and the bonds of blood, *Moonstruck* will melt the hearts of moon-ruled viewers. Bravo!

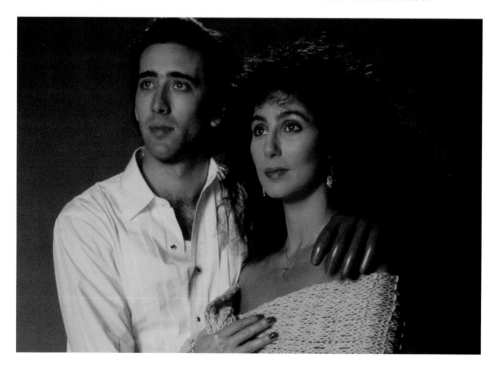

THE ARTIST
(2011)

Cancers, fearing rejection, rarely make the first move in love. In writer/director Michel Hazanavicius's affectionate ode to silent movies, silver-screen idol George Valentin (Jean Dujardin) and ambitious ingénue Peppy Miller (Bérénice Bejo) delay admitting their feelings for each other, almost until it's too late. Though George and Peppy seem to experience love at first sight, it takes a while to bridge the gulf between them. Elegant and touching, this story of a Hollywood friendship destined to blossom into romance is shot in beautiful shades of black and white, and symphonically scored (sans spoken dialogue) in the grand silent-film tradition. For a date night with a crab, immerse yourself in the old-fashioned charm of *The Artist*, an uplifting crowd-pleaser that nabbed the Oscar for Best Picture against all odds.

ABOVE: Jean Dujardin and Bérénice Bejo experience love at first sight in *The Artist*. OPPOSITE: Nicolas Cage and Cher gaze at a full moon in *Moonstruck*.

Cancer Comedies

BLAST FROM THE PAST
(1999)

Grown-up Cancers often retain a childlike charm. They're also attached to their parents, and can sometimes find it hard to leave the nest and strike out on their own. In the kookily endearing *Blast from the Past,* Brendan Fraser is Adam, a typically Cancerian male—to the extreme. After being raised in a bomb shelter by his square mom and dad (Sissy Spacek and Christopher Walken) since the mid-1960s, adorably backward Adam finally enters the real world at age thirty-five. Only Eve (Alicia Silverstone) sees the potential in Adam. He may be a midcentury relic of the past, but he's the most genuinely darned polite guy she's ever met in LA. Their touching love story is awkward, funny, and peppered with Perry Como songs. Enjoy responsibly with a champagne cocktail.

70

MIDNIGHT IN PARIS
(2011)

Cancer, have you ever longed to escape the hassles of modern-day life and journey back to the artistic paradise that was 1920s Paris? Well, that's exactly what happens to Gil (Owen Wilson), a guileless screenwriter whose nostalgic dreams come true when he stumbles on a magical portal to the past while visiting France with his ill-tempered bride-to-be (Rachel McAdams). Every night at midnight, Gil is transported to the Jazz Age, where he mingles till dawn with the likes of Ernest Hemingway, Cole Porter, and Pablo Picasso, and falls for a beautiful artist's model (Marion Cotillard). *Midnight in Paris*, Woody Allen's sly comment on nostalgia and a lighthearted love letter to the City of Lights, was practically tailor-made for the Cancer-born.

ABOVE: Owen Wilson dreams of escaping to the past in *Midnight in Paris*. OPPOSITE: Alicia Silverstone and Brendan Fraser in *Blast from the Past*.

Cozy Cancer Classics

NOW, VOYAGER
(1942)

In this gloriously dignified romance, spinster homebody Charlotte (Bette Davis) breaks away from her domineering mother (Gladys Cooper) and morphs into a glamorous lady of the world. After some therapy with an understanding psychiatrist (Claude Rains) and a much-needed makeover, Charlotte becomes her own independent woman at last. When she takes a cruise and falls for the married Jerry (Paul Henreid), their secret love affair lives on in their hearts forever—even if they never act on their feelings again. "Don't let's ask for the moon," Charlotte tells Jerry. "We have the stars." *Now, Voyager* is a superb example of what the more reserved crabs can accomplish with a little nudge out of their shells.

REBEL WITHOUT A CAUSE
(1955)

Nicholas Ray's acclaimed juvenile-delinquent drama is not, in fact, a movie about rebellion, but about the need for familial love. Troubled teen Jim (James Dean), misunderstood Judy (Natalie Wood), and lonely Plato (Sal Mineo) run away from their clueless parents and form their own makeshift family in a deserted old mansion—a perfect Cancer fantasy. Water babies can experience a rainbow of moods in a single day, just like the moody teens in *Rebel*, who share the highs and lows of a drag race gone tragically wrong. As Jim and Judy fall in love, they find the stability that's missing from their households. "Nobody talks to children," Jim says. "No," Judy adds. "They just tell them." Sensitive crabs will need a couple of hankies for this one.

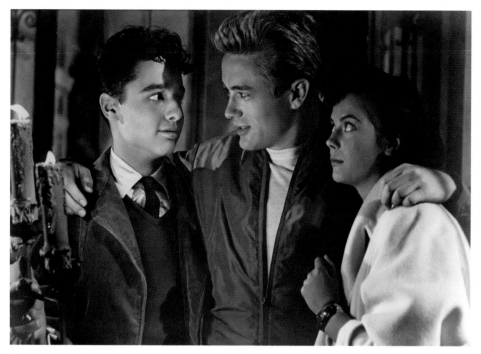

Sal Mineo, James Dean, and Natalie Wood form a makeshift family in *Rebel Without a Cause*.

Continued Viewing for Cancer

THE KID (1921)	*FORREST GUMP* (1994)
STELLA DALLAS (1937)	*THAT THING YOU DO!* (1996)
IT'S A WONDERFUL LIFE (1946)	*FOUR LITTLE GIRLS* (1997)
EVERY GIRL SHOULD BE MARRIED (1948)	*AN EDUCATION* (2009)
THE 400 BLOWS (1959)	*THE MUPPETS* (2011)
AMERICAN GRAFFITI (1973)	*X-MEN: DAYS OF FUTURE PAST* (2014)
TERMS OF ENDEARMENT (1983)	*ROBIN WILLIAMS: COME INSIDE MY MIND* (2018)
RAISING ARIZONA (1987)	

PARTNERING UP WITH
CANCER

Wondering what to pick if you're watching with a movie buddy or significant other? Wonder no more!

CANCER AND ARIES
Love with the Proper Stranger
(1963)

Watch Cancerian Natalie Wood and Aries Steve McQueen generate sparks in their only screen pairing. There's so much more depth here than your typical rom-com.

CANCER AND GEMINI
Apollo 13
(1995)

This epic historical drama illustrates the problems encountered by the 1970 space mission, and the gamut of emotions felt by the astronauts' wives and children back on earth.

CANCER AND TAURUS
Roma
(2018)

Filmmaker Alfonso Cuarón channels his Mexican childhood into an award-winning character study. Cancer and Taurus together will soak up the aesthetic richness of this personal reminiscence.

CANCER AND LEO
Hugo
(2011)

Not just a movie for children, Martin Scorsese's youthful fantasy is about history, family, memory, illusion, and showbiz. Topics suited to both crab and lion.

CANCER AND VIRGO
Back to the Future
(1985)

Robert Zemeckis's classic time-travel comedy features midcentury madness aplenty for sentimental Cancer, and a neatly tied plot for tidy Virgo to appreciate.

CANCER AND LIBRA
Won't You Be My Neighbor?
(2018)

This affectionate documentary examines Fred Rogers, a true champion of children (Cancer) and a subtle but steady force of social justice (Libra) for generations.

CANCER AND CAPRICORN
I, Tonya
(2017)

The dramatized life story of Olympic figure-skater Tonya Harding (starring and co-produced by Cancerian actress Margot Robbie) reveals the family dysfunction (Cancer) behind the quest for career glory (Capricorn).

CANCER AND SCORPIO
Born on the Fourth of July
(1989)

Cancer star Tom Cruise received his first Oscar nom for this true story about a Vietnam veteran. Scorps will revel in the dark side of patriotism; crabs will say, "Pass the Kleenex."

CANCER AND AQUARIUS
Coma
(1977)

Actress Genevieve Bujold (born July 1) displays that notorious Cancer tenacity in this forward-thinking sci-fi thriller, as a doctor who won't stop investigating mysterious deaths in her hospital—even when her life is at stake.

CANCER AND SAGITTARIUS
The Young Girls of Rochefort
(1967)

Jacques Demy's enchanting musical starring Catherine Deneuve offers a quaint storybook romance for Cancer, and vibrant French escapism for Sag. Ooh la la!

CANCER AND PISCES
Splash
(1984)

Cancer Tom Hanks hilariously falls in love with a mermaid, which is a totally crab thing to do. Being a mermaid, meanwhile, is a totally Piscean thing. May they live watery ever after.

See also the eleven other "Partnering Up" sections for more sign-compatible recommendations.

≥ CANCER HIDDEN GEM ≤

For your next classic-movie night, Cancer, treat yourself to the 1943 musical *Stormy Weather*. Here, Cancerian leading lady Lena Horne sparkles in her signature role as a talented nightclub singer torn between career and marriage. Her domestic desires may win out (typical crab), but not before she croons the title song like no one else in history.

CANCER STARS

KEVIN BACON
(July 8)

LENA HORNE
(June 30)

JAMES CAGNEY
(July 17)

JANET LEIGH
(July 6)

LESLIE CARON
(July 1)

TOBEY MAGUIRE
(June 27)

TOM CRUISE
(July 3)

MARGOT ROBBIE
(July 2)

BENEDICT CUMBERBATCH
(July 19)

GINGER ROGERS
(July 16)

OLIVIA DE HAVILLAND
(July 1)

SYLVESTER STALLONE
(July 6)

WILL FERRELL
(July 16)

BARBARA STANWYCK
(July 16)

HARRISON FORD
(July 13)

MERYL STREEP
(June 22)

TOM HANKS
(July 9)

ROBIN WILLIAMS
(July 21)

KEVIN HART
(July 6)

NATALIE WOOD
(July 20)

OPPOSITE: Cancer actress Lena Horne in *Stormy Weather*.

LEO

JULY 23–AUGUST 22

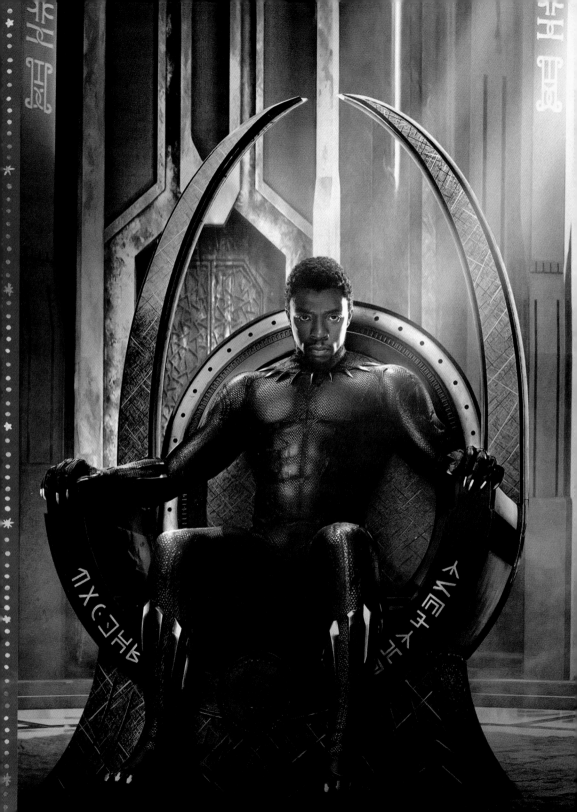

LIKE ITS RULER, THE SUN, EVERYTHING REVOLVES AROUND LEO

the lion. This warm, flamboyant fire sign can be self-absorbed, and yet, paradoxically, Leos are among the most generous people you will ever meet. Their hearts are as big as their egos. They live to be worshipped. Once you accept that they are in command, they will adore you in return with an everlasting devotion, and defend you with the courage of a lion. Pride is their only Achilles' heel (flattery will get you everywhere with a Leo). Magnanimous, sunny, and extroverted, Leos are drawn to the dramatic; they naturally take center stage and lap up attention, making excellent leaders, bosses, and performers—even kings or queens (the ancients associated the constellation of Leo with royalty). The most charismatic lions literally end up in the movies or on the stage, and even Leos who don't pursue an entertainment career tend to be loyal fans, absorbing all the Hollywood news and devouring their favorite films and TV shows. Either way, Leo is always the star of his or her world. Everyone else is just along for the ride.

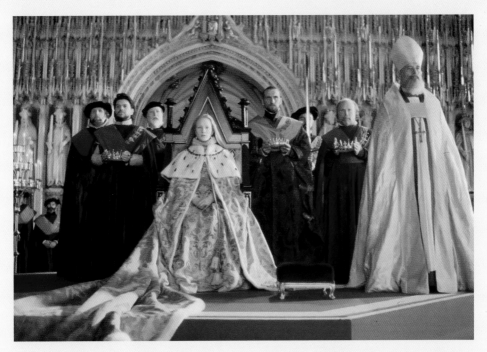

Cate Blanchett takes the throne in *Elizabeth*. OPPOSITE: Chadwick Boseman as the super-powered T'Challa in *Black Panther*.

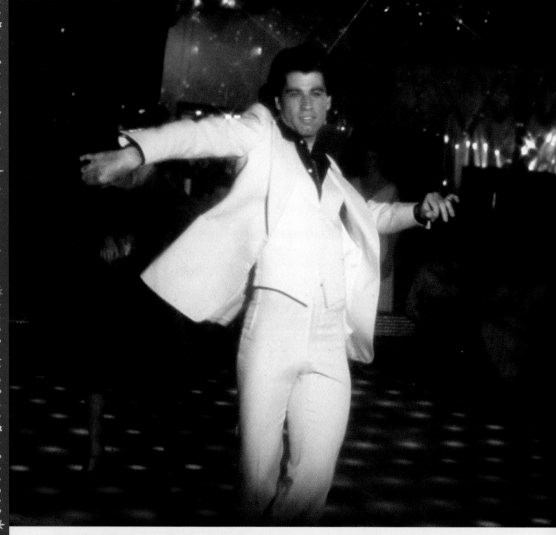

John Travolta struts across the dance floor in *Saturday Night Fever*.

If you're born under the sign of Leo, odds are you enjoy big-budget, larger-than-life movies with awe-inspiring effects, à la *Jurassic Park* (1993), *King Kong* (2005), and *Avatar* (2009). Being the queen or king of the zodiac, you may indulge in sumptuous sagas about royalty, or about those who attain greatness. *Elizabeth* (1998), starring Cate Blanchett as Queen Elizabeth I of England; *Evita* (1996), leonine lady Madonna's star turn as the controversial wife of the president of Argentina; and Disney's epic musical *The Lion King*, both the animated 1994 original and the live-action 2019 version, depict that regal radiance that Leo loves.

The Hollywood superhero craze resonates with you, Leo. Those ruled by the sun can be heroic, even putting their own needs aside (momentarily) to save others from danger. From *Superman* (1978) to *Iron Man* (2008), from *Black Panther* (2018) to *Captain Marvel* (2019), superpowered saviors inspire your desire to be a force for good in the world.

Movies about show business (or show-offs) also speak to lions because—let's face it—Leos ooze star quality. In the disco-delightful *Saturday Night Fever* (1977), the lead character (Tony, played by John Travolta) starts out stuck in his lion-sized ego and image, but learns to build a real self beneath the strut. The snazzy *All That Jazz* (1979), loosely based on choreographer Bob Fosse's life; *The Bodyguard* (1992), a glamorous vehicle for Leo pop diva Whitney Houston; and *Rocketman* (2019), a glitzy telling of Elton John's wild ride, are showbiz dramas that make lions purr.

Leos are natural-born movie directors. In fact, there may be more of them in Hollywood history than any other sign! They think big, they have an innate sense of the theatrical, and their authoritative personalities demand respect. In addition to the recommendations that follow, check out the work of Leo filmmakers Kathryn Bigelow, Peter Bogdanovich, James Cameron, Wes Craven, Cecil B. DeMille, Blake Edwards, Greta Gerwig, Alfred Hitchcock, John Huston, Alejandro Innaritu, Patty Jenkins, Stanley Kubrick, John Landis, Richard Linklater, Sam Mendes, Christopher Nolan, Roman Polanski, Patricia Rozema, M. Night Shyamalan, Kevin Smith, Gus van Sant, and Taika Waititi.

ASTRO-INFO

The sign of Leo is associated with the movie industry in general. From Leo the Lion (the M-G-M mascot) to the abundance of directors and stars born between July 23 and August 22, Hollywood is usually considered a Leo-dominant town.

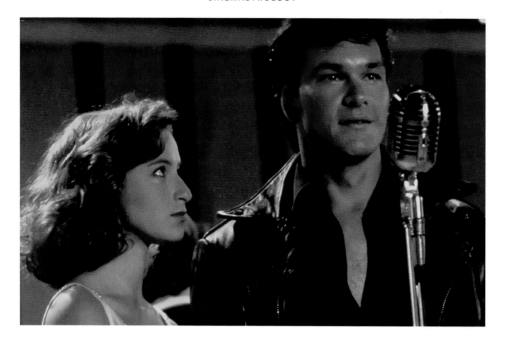

Leo Date Movies

DIRTY DANCING
(1987)

In this smash hit 1980s movie, set in the early 1960s, Leo Patrick Swayze plays hunky resort entertainer Johnny, and Jennifer Grey is the young dancer-in-training called Baby. Against a backdrop of sexy dancing and the best Motown-flavored soundtrack since *The Big Chill* (1983), Johnny teaches Baby more than just mambo moves as they fall passionately for each other during a summer in the Catskills. The problem with Leo performers is that they want the stage all to themselves. But in *Dirty Dancing*, Johnny lets Baby shine; he instructs her, encourages her talents, and ensures that she gets noticed, making theirs an ideal partnership. Screen this gem on your next rendezvous with a lion, but be warned: nobody puts Leo in a corner.

The Hollywood superhero craze resonates with you, Leo. Those ruled by the sun can be heroic, even putting their own needs aside (momentarily) to save others from danger. From *Superman* (1978) to *Iron Man* (2008), from *Black Panther* (2018) to *Captain Marvel* (2019), superpowered saviors inspire your desire to be a force for good in the world.

Movies about show business (or show-offs) also speak to lions because—let's face it—Leos ooze star quality. In the disco-delightful *Saturday Night Fever* (1977), the lead character (Tony, played by John Travolta) starts out stuck in his lion-sized ego and image, but learns to build a real self beneath the strut. The snazzy *All That Jazz* (1979), loosely based on choreographer Bob Fosse's life; *The Bodyguard* (1992), a glamorous vehicle for Leo pop diva Whitney Houston; and *Rocketman* (2019), a glitzy telling of Elton John's wild ride, are showbiz dramas that make lions purr.

Leos are natural-born movie directors. In fact, there may be more of them in Hollywood history than any other sign! They think big, they have an innate sense of the theatrical, and their authoritative personalities demand respect. In addition to the recommendations that follow, check out the work of Leo filmmakers Kathryn Bigelow, Peter Bogdanovich, James Cameron, Wes Craven, Cecil B. DeMille, Blake Edwards, Greta Gerwig, Alfred Hitchcock, John Huston, Alejandro Innaritu, Patty Jenkins, Stanley Kubrick, John Landis, Richard Linklater, Sam Mendes, Christopher Nolan, Roman Polanski, Patricia Rozema, M. Night Shyamalan, Kevin Smith, Gus van Sant, and Taika Waititi.

ASTRO-INFO

The sign of Leo is associated with the movie industry in general. From Leo the Lion (the M-G-M mascot) to the abundance of directors and stars born between July 23 and August 22, Hollywood is usually considered a Leo-dominant town.

Lavish Leo Faves

THE LAST EMPEROR
(1987)

Italian maestro Bernardo Bertolucci's sweeping historical epic captures the pomp, the circumstance, the grandeur of China's final days as an empire. The visual details alone make for eye-popping entertainment; dazzling ceremonial colors of red and gold saturate the film. But it's really the story of one man's incredible life. Crowned emperor at the age of three, young Puyi (played as an adult by John Lone) is given complete authority, yet denied his freedom. Leo may fantasize about being a supreme ruler, but the reality of such a position is less than fulfilling. Majesty and privilege, combined with strict regimentation and, finally, imprisonment, make Puyi's life a royal roller coaster. This gorgeously crafted biopic took home nine Oscars, including the Best Picture of 1987. Outside of Disney fare and comic-book spectacles, they just don't make movies this big anymore.

Richard Vuu as Emperor Puyi in *The Last Emperor.* OPPOSITE: Anika Noni Rose, Beyoncé Knowles, and Jennifer Hudson show off their talent in *Dreamgirls.*

DREAMGIRLS

(2006)

Becoming a celebrity requires talent, hard work, and a lot of dreaming. All three play a role in director Bill Condon's screen adaptation of the Broadway musical *Dreamgirls*, a song-filled Cinderella story, loosely based on the rise of the Supremes. The note-perfect cast—led by Beyoncé Knowles, Jamie Foxx, Jennifer Hudson, and Eddie Murphy—shimmer and shine in the backstage world of 1960s girl groups. Dripping with attitude, elegance, and ultra-fabulous retro fashions, the Dreams experience the turbulence of the '60s (and endure personal dramas) as their fame and wealth skyrocket. "I'm somebody, somebody, and nobody's gonna hold me down," the ladies sing at the height of their success. Self-assured Leo can be heard singing along.

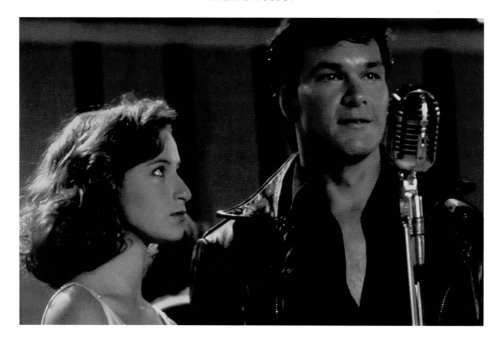

Leo Date Movies

DIRTY DANCING
(1987)

In this smash hit 1980s movie, set in the early 1960s, Leo Patrick Swayze plays hunky resort entertainer Johnny, and Jennifer Grey is the young dancer-in-training called Baby. Against a backdrop of sexy dancing and the best Motown-flavored soundtrack since *The Big Chill* (1983), Johnny teaches Baby more than just mambo moves as they fall passionately for each other during a summer in the Catskills. The problem with Leo performers is that they want the stage all to themselves. But in *Dirty Dancing*, Johnny lets Baby shine; he instructs her, encourages her talents, and ensures that she gets noticed, making theirs an ideal partnership. Screen this gem on your next rendezvous with a lion, but be warned: nobody puts Leo in a corner.

A STAR IS BORN

(ALL FOUR VERSIONS)

Even Leos can sometimes be hesitant to let their natural star mojo flow; they may need a little push into the spotlight. Once there, they can roar like the lions we always knew they were. In the 2018 update of *A Star Is Born*, Lady Gaga (like Janet Gaynor in 1936, Judy Garland in 1954, and Barbra Streisand in 1976) needs loving support to explode like a supernova. Bradley Cooper (who also directs) plays Jackson Maine, an alcoholic musician who fosters the burgeoning career of singer Ally (Gaga) as his fame takes a tumble. It's an authentically dramatic Leo love story. Be sure to also catch the earlier versions for a taste of Judy Garland's best work, and to see this rise-and-fall romance interpreted differently through the various decades.

Judy Garland shines in *A Star Is Born* (1954).

Leo Comedies

BOWFINGER
(1999)

When Leo actor/comedian/writer Steve Martin teams up with fellow fire sign, Aries Eddie Murphy, the comic sparks seriously fly. Bobby Bowfinger (Martin) always dreamed of being a bigshot Hollywood producer, but, at midlife, he realizes that his goals have not panned out. Desperate to make a name for himself (and give his out-of-work actor friends a job), Bobby pours his modest life savings into the ultimate low-budget film—so low, in fact, he doesn't pay his star, Kit Ramsey (Murphy), or even tell him he's in the movie! Hiring a ragtag film crew to follow the paranoid Kit with a hidden camera, Bobby bluffs his way into the big time on sheer ego (something Leo excels at) as he concocts a sci-fi thriller titled *Chubby Rain*. Murphy also plays Kit's dweeby brother, Jiff. And lots of laughter ensues.

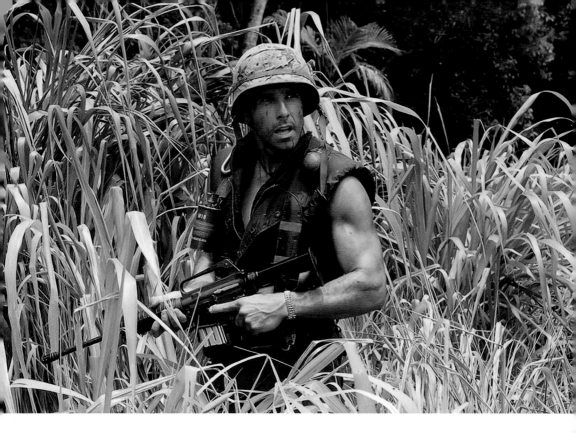

TROPIC THUNDER
(2008)

Ben Stiller stars in and directs this satirical swipe at Hollywood's most inflated egos. When the cast of a Vietnam War movie ends up stranded on location in Southeast Asia, the entitled actors are forced to grow real backbones if they want to make it out of the jungle alive. Featuring more explosions than necessary and no-holds-barred comic performances from the likes of Jack Black, Robert Downey Jr., Matthew McConaughey, and Tom Cruise, *Tropic Thunder* is at once dark, irreverent, and triumphant. Some of the most boundary-pushing gags (like fake graphic violence and the political incorrectness of Robert Downey Jr. in blackface) are not for the faint of heart, but it's all done in the name of parody, and Leos will appreciate the bold humor.

ABOVE: Ben Stiller in the Hollywood satire *Tropic Thunder*. OPPOSITE: Aries Eddie Murphy and Leo Steve Martin team up in *Bowfinger*.

Star-Studded Leo Classics

I'M NO ANGEL
(1933)

Leo legend Mae West wrote this sass-fest for herself, and it's one of her greatest. A leonine theme permeates the comedy, which is chock-full of her iconic one-liners. "When I'm good I'm very good. But when I'm bad, I'm better," she promises—and is indeed a badass as the rich and famous lion tamer Tira. This blonde bombshell bravely puts her head inside a lion's mouth, and visits an astrologer who reads her horoscope. "You were born under the sign of Leo the lion," he informs her. "Oh, king of the beasts, huh?" asks West, a devilish glint in her eye. In movies and in life, Mae embodied the Leo traits of courage and confidence, not to mention that sultry fire-sign sex appeal. Here, she sets the screen on fire in the biggest box-office hit of 1933.

ABOVE: Leo Mae West and her lion friend in *I'm No Angel*. OPPOSITE: Ruby Keeler taps her way to stardom in *42nd Street*.

42ND STREET

(1933)

"You're going out there a youngster," stage director Julian Marsh (Warner Baxter) tells tap-dancing dynamo Peggy Sawyer (Ruby Keeler) before her stage debut, "But you've got to come back a star!" In the groundbreaking backstage musical *42nd Street*, Peggy taps her way to glory when she replaces the injured star (Bebe Daniels) on opening night of a Broadway show. Catchy tunes, outlandish Busby Berkeley choreography, racy pre-Code humor, and a few dramatic twists make this often-emulated classic a must-see for a showbiz-loving Leo. The ensemble cast—including dreamy crooner Dick Powell and a saucy young Ginger Rogers just before she teamed up with Fred Astaire—gives it their all. Put your paws together for this rousing musical, lions.

Continued Viewing for Leo

CITIZEN KANE (1941)

WHITE HEAT (1949)

SINGIN' IN THE RAIN (1952)

THE KING AND I (1956)

THE PRODUCERS (1967)

ANNE OF THE THOUSAND DAYS (1969)

THE MUPPET MOVIE (1979)

FAME (1980)

COMING TO AMERICA (1988)

TERMINATOR 2: JUDGMENT DAY (1991)

QUIZ SHOW (1994)

TO DIE FOR (1995)

HOLLYWOODLAND (2006)

THE LAST KING OF SCOTLAND (2006)

AMERICAN HUSTLE (2013)

⇒ LEO HIDDEN GEM ⇐

If you're in the mood for a different kind of documentary, seek out Chuck Workman's colorful *Superstar: The Life and Times of Andy Warhol* (1990). Warhol was a true Leo-born original who brought a movie-star sensibility to the art world by painting portraits that flattered the famous— and certain soup cans.

PARTNERING UP WITH
LEO

Wondering what to pick if you're watching with a movie buddy or significant other? Wonder no more!

LEO AND ARIES
Hell or High Water
(2016)

Action (Aries) and bravado (Leo) drive this contemporary Western about two bank-robbing brothers who—it turns out— have more integrity than we initially see.

LEO AND GEMINI
The Death of Stalin
(2018)

The high-stakes power struggle when tyrannical leader Joseph Stalin dies is played for laughs in this cleverly absurd Russian-set comedy.

LEO AND TAURUS
Love's Labour's Lost
(2000)

When Kenneth Branagh adapts a comedy by William Shakespeare (a Taurus) into a splashy, old-Hollywood-style musical, both lions and bulls have something to sing about.

LEO AND CANCER
Best Foot Forward
(1943)

Lucille Ball (a Leo) looks stunning in Technicolor as a big star surrounded by throngs of admiring youngsters when she appears at their school.

LEO AND VIRGO
Bohemian Rhapsody
(2018)

Flamboyant Virgo rock star Freddie Mercury (Rami Malek) and his band Queen come to life in Bryan Singer's flashy, foot-stomping biopic.

OPPOSITE: Artist Andy Warhol, a Leo, directs a film.

LEO AND LIBRA
Hail, Caesar!
(2016)

In this offbeat journey back to a 1950s movie studio, George Clooney (as a shallow, egotistical actor) leads the ensemble cast of crazies who struggle to coexist peacefully with each other.

LEO AND CAPRICORN
Joy
(2015)

It's a Capricorn dream come true when Leo Jennifer Lawrence climbs from struggling mom to self-made millionaire as Joy Mangano, the inventor of the self-wringing mop.

LEO AND SCORPIO
Rear Window
(1954)

Master of suspense (and Leo) Alfred Hitchcock presents what may be his most brilliant movie. Immensely entertaining, with cynical, sinister, and sexy undercurrents for the Scorps.

LEO AND AQUARIUS
Total Recall
(1990)

Leo Arnold Schwarzenegger plays a spy with falsified memories in the year 2084. Showy enough for lions, thought-provoking enough for Aquarians.

LEO AND SAGITTARIUS
Bye Bye Birdie
(1963)

Starstruck Leo and happy-go-lucky Sag will both dig this: A swell-headed rock star comes to the Midwest, and the townsfolk erupt into buoyant, gleeful songs in celebration.

LEO AND PISCES
Desperately Seeking Susan
(1985)

Mistaken identity, amnesia, and the chance to live out your wildest fantasies are the Piscean subjects of this rom-com, starring Leo lovelies Rosanna Arquette and Madonna.

See also the eleven other "Partnering Up" sections for more sign-compatible recommendations.

LEO STARS

AMY ADAMS
(August 20)

MADONNA
(August 16)

BEN AFFLECK
(August 15)

STEVE MARTIN
(August 14)

LUCILLE BALL
(August 6)

SEAN PENN
(August 17)

HALLE BERRY
(August 14)

DANIEL RADCLIFFE
(July 23)

SANDRA BULLOCK
(July 26)

ROBERT REDFORD
(August 18)

STEVE CARELL
(August 16)

ARNOLD
SCHWARZENEGGER
(July 30)

ROBERT DE NIRO
(August 17)

HILARY SWANK
(July 30)

MILA KUNIS
(August 14)

CHARLIZE THERON
(August 7)

JENNIFER LAWRENCE
(August 15)

MAE WEST
(August 17)

JENNIFER LOPEZ
(July 24)

VIRGO

AUGUST 23–SEPTEMBER 22

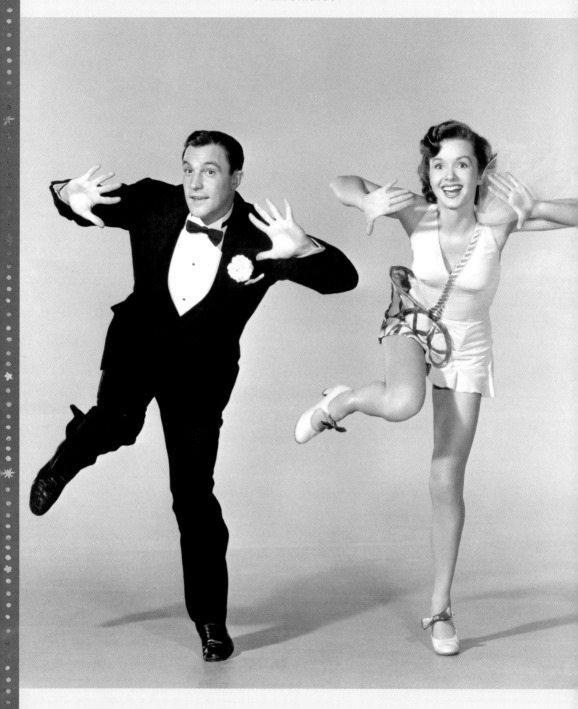

In *The Best of Everything*, Hope Lange embodies the Virgo work ethic. OPPOSITE: Gene Kelly (here with Debbie Reynolds) lends his Virgo touch to *Singin' in the Rain*.

PRAGMATIC VIRGO IS THE HARDWORKING HELPER OF THE ZODIAC.

An earth sign governed by Mercury, Virgo is all about being useful to others, whether that means volunteering, assisting, or just being a trusted friend. And Virgoans rock at it. You can always count on Virgoans to get the job done right because they are perfectionists. The Virgo-born have a reputation for being clean, organized, and disciplined. Their nature is symbolized by the virgin, the maiden of the autumn harvest, who must be particular and exacting when separating the wheat from the chaff. From this essence stems Virgo's immaculate taste and high standards. Being children of Mercury, virgins communicate directly—even critically at times, but always constructively so. They speak their truth. They also demand top-notch, classy entertainment, and are unwilling to waste a second of their time on a lame movie (oh, yes, they *will* walk out of the theater

In *Broadcast News*, Holly Hunter and William Hurt embark on a workplace romance.

if they're displeased!). Virgo dancer/actor/director Gene Kelly embodied the archetype with his precision and attention to detail. Watch not only Kelly's flawless dancing and choreography in *Singin' in the Rain* (1952), but his finely tuned directorial work in the exquisite *Hello, Dolly!* (1969).

Virgo, like your Mercury-ruled cousin Gemini, you are a thinker with an affinity for the written word. You would make a great teacher, librarian, writer, or critic—and you devour movies about these subjects. *Colette* (2018), a biopic of the famous French author, depicts her creative writing process, plus the difficulty she faced getting credit for her work. In *The Best of Everything*, a 1959 melodrama set in the Manhattan publishing world, ingénue Hope Lang plays a Virgo-type character. An aspiring book editor, she's smart and eager to be helpful. She strives to be a "good girl," yet finds it hard to suppress her desires.

Despite the obvious connotation, Virgo is no more virginal than any other sign! In fact, these virgins can be sexually forthright and quite earthy when they meet that special someone. Whether you're in the mood for love or work, Virgo, workplace romances like *Broadcast News* (1987), *The Hudsucker Proxy* (1994), and even the kinky *Secretary*

(2002) are likely to strike your finicky fancy—especially since your playtime often over-laps into your long working hours.

As a Virgo, you're naturally analytical, and probably fascinated by psychoanal-ysis; you may even practice armchair psychology on your friends and family. Pixar's *Inside Out* (2015) is a psychological fairy tale tailor-made for the Virgo-born; *Analyze This* (1999) is a less family-friendly option. Then there's *Hamlet* (1996)—talk about a guy who overanalyzes everything. In Kenneth Branagh's adaptation, the prince of Denmark spends four hours pondering and wallowing in his thoughts, which should serve as a cautionary tale for Virgos who overthink things (spoiler alert: It doesn't end well).

Virgoans tend to make excellent movies because they never take sloppy shortcuts or settle for less than the best, even if it means going into overtime. In addition to the recommendations that follow, try exploring the work of Hal Ashby, Tim Burton, Ethan Coen, Chris Columbus, Brian De Palma, Ava DuVernay, David Fincher, Elia Kazan, Baz Luhrmann, Guy Ritchie, Joel Schumacher, Oliver Stone, Preston Sturges, Erich von Stro-heim, and Robert Wise, a sampling of filmmakers born under the sign of Virgo.

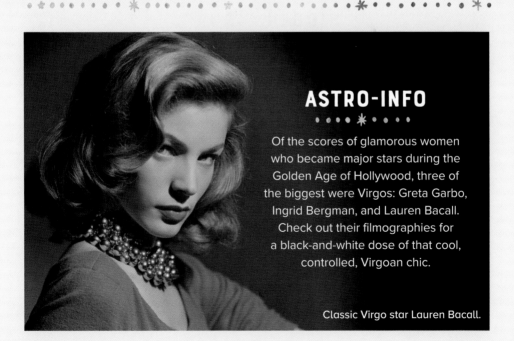

ASTRO-INFO

Of the scores of glamorous women who became major stars during the Golden Age of Hollywood, three of the biggest were Virgos: Greta Garbo, Ingrid Bergman, and Lauren Bacall. Check out their filmographies for a black-and-white dose of that cool, controlled, Virgoan chic.

Classic Virgo star Lauren Bacall.

Very Virgo Picks

HIDDEN FIGURES
(2016)

What is the ultimate Virgo fantasy, you ask? Being showered with praise after toiling away anonymously for years, of course. In this fact-based movie, set in the 1960s, three dedicated ladies who work quietly behind the scenes finally get the recognition they deserve. Virgo actress Taraji P. Henson portrays Katherine Johnson, a brainiac with an exceptional gift for math who becomes the first black woman to calculate trajectories for NASA's manned space flights. When Katherine tells her boss (Kevin Costner) exactly what she thinks of the discrimination she faces in the workplace, conditions begin to improve for her and her two friends (Octavia Spencer and Janelle Monae), and they eventually name a building after her. Fun fact: The real Katherine Johnson was a Virgo who celebrated 101 birthdays before her death in 2020.

ABOVE: Taraji P. Hensen as real-life Virgo Katherine Johnson in *Hidden Figures*. OPPOSITE: Harry Potter (Daniel Radcliffe) needs the help of Virgo Hermione Granger (Emma Watson) to save the world.

HARRY POTTER AND THE PRISONER OF AZKABAN

(2004)

Daniel Radcliffe is the ideal Harry Potter, but the boy wizard would be in big trouble without his bookish (and totally Virgoan) friend Hermione Granger (Emma Watson), who uses her skills to help Harry save the world. Whip-smart, obsessed with making perfect grades, and often called a "know-it-all" by haters, Hermione doesn't merely seem like a Virgo; author J. K. Rowling has given her a birthday of September 19, making this character officially born under the sign of the virgin. In Alfonso Cuarón's *Prisoner of Azkaban*, Hermione is in rare form. The lives of virtually everyone in this story depend on her ability to think logically under pressure, making her the movie's hero. Plus, the neatly tied story will appeal to Virgo's intolerance for dangling plot threads. Watch this third in your Harry Potter marathon.

Virgo Date Movies

STRANGER THAN FICTION
(2006)

The romance at the heart of this intelligent, life-affirming comedy is between two unlikely lovers: repressed IRS auditor Harold Crick (Will Ferrell) and free-spirited baker Ana (Maggie Gyllenhaal). When Harold hears the voice of Karen Eiffel (Emma Thompson)—a nihilistic novelist with a bad case of writer's block—narrating his own life, he consults a literature professor (Dustin Hoffman) who advises him to reclaim his destiny. A thought-provoking flick in which fiction and fact collide, *Stranger Than Fiction* appeals to Virgo's literary leanings while also delivering a realistic love affair. Harold and Ana may seem like opposites, but once she feeds him homemade cookies, they click in an authentic, believable way. And that's important for practical-minded Virgo. Screen this one with a supply of cookies and milk.

FOUR WEDDINGS AND A FUNERAL
(1994)

Virgo Hugh Grant shot to superstardom by playing a rather un-Virgo-like character in this wildly popular British rom-com. Charlie never quite says or does the right thing. He's always late, disorganized, and stumbling over his words, as he blurts out crass and inappropriate observations that make others cringe. But his charm lies in his imperfections—and his honesty. He knows that marriage isn't for him, but that doesn't mean he should be denied a shot at real love. Virgos will root for Charlie to speak his truth, to clearly state his innermost desires, which he ultimately does, thanks to writer/director Richard Curtis's splendid script, which drips with humor and veracity. As Charlie's ideal woman, Andie MacDowell is beautiful, bright, and warm. When these two finally get together, we want it to last forever.

OPPOSITE: Andie MacDowell and Hugh Grant on the set of *Four Weddings and a Funeral.*

Virgo Comedies

THE ODD COUPLE
(1968)

The big-screen adaptation of Neil Simon's beloved play gives Virgo viewers a lot to laugh about. As the hyper-fastidious Felix Ungar, Jack Lemmon raises the bar for fictional neat freaks and drives his slovenly roommate Oscar (Walter Matthau) to the brink of insanity by dusting and disinfecting everything in sight. Whether you're the type who likes things tidy or the word-obsessed variety of virgin, the jokes here are on the nose. "In other words, you're throwing me out?" Felix asks. "Not in other words," Oscar replies. "Those are the perfect ones." The 1970s TV series (with Tony Randall as Felix and Jack Klugman as Oscar) this hit inspired was so popular that it almost eclipsed the movie. For a comedy impeccable enough to meet even Virgo's lofty standards, rediscover the original *Odd Couple*.

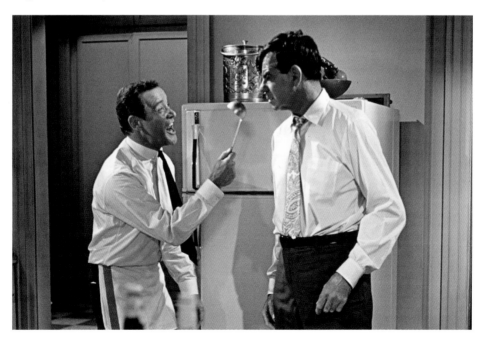

AS GOOD AS IT GETS
(1997)

True-to-life dialogue that also happens to be scathingly funny—that's the brand of humor that resonates with Virgos. This neurotic comedy-drama by James L. Brooks boasts a ton of truisms about New York City life, and about people in general. Jack Nicholson is obsessive-compulsive novelist Melvin Udall, a cranky middle-aged man imprisoned by his own phobias—namely germs and interacting with other people—whose heart grows a little bigger when he helps his favorite waitress, Carol (Helen Hunt), pay her son's medical bills. Like life itself, sometimes this dramedy is hilarious, sometimes downright devastating. "What if this is as good as it gets?" asks Melvin when reality comes crashing down around him. This is a fable that inspires us to keep going. And who knows? Things just might get rosier.

ABOVE: Jack Nicholson gets chummy with his neighbor's dog in *As Good As It Gets*. OPPOSITE: Jack Lemmon and Walter Matthau in *The Odd Couple*.

PARTNERING UP WITH
VIRGO

Wondering what to pick if you're watching with a movie buddy or significant other? Wonder no more!

VIRGO AND ARIES
Sense and Sensibility
(1995)

Aries Emma Thompson not only stars in this thinking person's romance, but adapted the Jane Austen novel into a subtly beautiful screenplay.

VIRGO AND GEMINI
Who Framed Roger Rabbit?
(1988)

Virgos will enjoy trying to solve this wily whodunit, while Gems will stay entertained thanks to the nonstop gags and outrageous toon characters.

VIRGO AND TAURUS
The Tree of Life
(2011)

Graceful and profound, Terrence Malick's quietly mesmerizing family epic rewards viewers with brains and patience, such as Virgoans and Taureans.

VIRGO AND CANCER
The Heiress
(1949)

Watch Cancer actress Olivia de Havilland slowly transform from sheltered to savvy in this penetrating psychological drama, also starring Montgomery Clift.

VIRGO AND LEO
The Truman Show
(1998)

When Truman Burbank (Jim Carrey) realizes that his life is being broadcast as a TV show without his consent, the Leo realm of entertainment meets the unvarnished reality of Virgo.

VIRGO AND LIBRA
An Ideal Husband
(1999)

Libran wit Oscar Wilde wrote the play this eloquent drawing-room comedy was based on. Debonair Rupert Everett is both wordy and worldly.

VIRGO AND CAPRICORN
Birdman
(2014)

This pitch-black comedy, starring Virgo actor Michael Keaton, appeals to these two earth signs because they don't mind facing the worst-case scenario—and laughing at it.

VIRGO AND SCORPIO
Bullets over Broadway
(1994)

In the crime-ridden world of 1920s Chicago, a young playwright sees his precious play torn apart by a critical mafia hitman who—it turns out—can write circles around him.

VIRGO AND AQUARIUS
Selma
(2014)

Virgo director Ava DuVernay illustrates the forward-thinking (i.e., Aquarian) men and women who followed Dr. Martin Luther King Jr. as he marched for civil rights in 1965 Alabama.

VIRGO AND SAGITTARIUS
An American in Paris
(1951)

This classic confection features Gene Kelly's meticulous yet effortless-looking dancing (for Virgo), and a thrilling French adventure for globe-trotting Sagittarius.

VIRGO AND PISCES
Sleepy Hollow
(1999)

Ichabod Crane (Johnny Depp) gets in over his head when he tries to apply Virgoan logic to a supernatural (Piscean) situation in this atmospheric Tim Burton thriller.

See also the eleven other "Partnering Up" sections for more sign-compatible recommendations.

⇒ VIRGO HIDDEN GEM ⇐

A criminally underrated Virgo actress with a natural, spontaneous style, Tuesday Weld is a performer worth rediscovering. Check out *Soldier in the Rain* (1963), *Lord Love a Duck* (1966), and *Pretty Poison* (1968) for a taste of Tuesday at her best.

VIRGO STARS

LAUREN BACALL
(September 16)

TOMMY LEE JONES
(September 15)

INGRID BERGMAN
(August 29)

GENE KELLY
(August 23)

JACK BLACK
(August 28)

BEYONCÉ KNOWLES
(September 4)

CLAUDETTE COLBERT
(September 13)

BLAKE LIVELY
(August 25)

CAMERON DIAZ
(August 30)

SOPHIA LOREN
(September 20)

GRETA GARBO
(September 18)

MELISSA MCCARTHY
(August 26)

RICHARD GERE
(August 31)

BILL MURRAY
(September 21)

HUGH GRANT
(September 9)

KEANU REEVES
(September 2)

SALMA HAYEK
(September 2)

JADA PINKETT SMITH
(September 18)

TARAJI P. HENSON
(September 11)

LILY TOMLIN
(September 1)

OPPOSITE: Tuesday Weld in *Pretty Poison*.

LIBRA

SEPTEMBER 23–OCTOBER 22

♀

AH, LOVELY LIBRA THE SCALES. AN AIR SIGN RULED BY GENTLE VENUS,
Libra is the only zodiac sign not symbolized by a living creature, but an object. Yet, iron-ically, Librans care deeply about humanity. Relationships are of utmost importance to them. In fact, they often define themselves through relationships with others—whether romantic, familial, or friendship. These autumn equinox babies were not meant to be alone (scales work best in pairs, don't they?). Like their fellow Venusians, Taurus, Librans cherish beauty and art. Unlike Taurus, there is no earth element to ground airy Libra, so they can get caught up in the art of appearances. Much may be simmering beneath the surface, but Librans maintain a placid exterior, keeping a smile on their pretty faces and every hair in place. These are the peacekeepers, the social justice warriors, always striv-ing for harmony—in a nonconfrontational way, of course. They want to get along with everyone. At the movies, happily-ever-after endings are their favorites.

Patrick Van Horn, Vince Vaughn, Jon Favreau, Ron Livingston, and Alex Desert live the night life in *Swingers*. OPPOSITE: Libra love goddess Rita Hayworth in *Cover Girl*.

Libra, deep down, you live for romance. Real life may be filled with disappoint-ment, but eternal love is easy to find in the movies: Just look for the word *love* in the title. *Love Affair* (1939), *Love Story* (1970), and *Love Actually* (2003) deliver that hope-less-romantic promise of everlasting *amour*. Being fond of glamour, scales guys and gals are naturally fashion-conscious. As a Libra, you may be drawn to couture-themed tales like *The Devil Wears Prada* (2006), *Coco before Chanel* (2009), or the Technicolor treat *Cover Girl* (1944), starring Libra love goddess Rita Hayworth as a dancer whose fair face graces a fashion magazine cover.

Aside from one-on-one relationships, Libra is also concerned with society as a whole. Librans lean toward entertainment that addresses social issues, films where jus-tice prevails in the end, and courtroom dramas (the scales of justice are Libran). *Twelve Angry Men* (1957) and *To Kill a Mockingbird* (1962) are classic Libra cinema. Then there are movies like Spike Lee's unpredictable *Inside Man* (2006) in which, against all the odds, the wrongs are righted and harmony is achieved in the final frame. The 1996 indie hit *Swingers*—cowritten by and starring Libran Jon Favreau—illustrates another scales tendency: to be social butterflies caught up in the nightlife whirlwind.

One might assume that life in Libra Land is incessantly even-steven and happy-go-lucky, but, alas, Librans can have their dark moments, too. The shadow side of the scales is social injustice, and the tragedies that can result from it. By turns funny, poignant, and devastating, Ridley Scott's 1991 landmark buddy movie *Thelma & Louise* (costarring Libra Susan Sarandon) confronts the harsh realities of gender inequality. Fritz Lang's *M* (1931) and Vittorio De Sica's *Bicycle Thieves* (1948) are two foreign classics that paint searing, unforgettable portraits of those who take justice into their own hands.

How does the sign of Libra express itself through the art of cinema? In addition to the recommendations that follow, watch the work of Libra-born filmmakers Pedro Almodovar, Michelangelo Antonioni, Danny Boyle, Guillermo del Toro, Catherine Hard-wicke, Spike Jonze, Mike Judge, John Krasinski, Penny Marshall, Steve McQueen (not the actor), and Denis Villeneuve to see the subtle social commentary and beauty that Libra brings to the screen.

OPPOSITE: Heather Matarazzo in Libra filmmaker Todd Solondz's *Welcome to the Dollhouse.*

⇒ LIBRA HIDDEN GEM ⇐

Independent Libra filmmaker Todd Solondz typically crafts movies about people struggling to fit neatly into their society. For a taste of his work, check out the suburban teen angst of *Welcome to the Dollhouse* (1995) and the disturbing family dysfunction of *Happiness* (1998).

Likely Libra Faves

A LEAGUE OF THEIR OWN
(1992)

Libra, you know there's no "I" in team. In Penny Marshall's big-screen tribute to the first professional female baseball league, surly manager Jimmy Dugan (Tom Hanks) learns that it's not about him; it's all about the ladies. As the Rockford Peaches—led by catcher Dottie (Geena Davis)—battle public criticism in an unenlightened era, they must also overcome personality clashes, not to mention Jimmy's disdainful attitude. Once every-one is onboard, cooperation and teamwork (Libra keywords)—and badass baseball skills, natch—land the girls in the World Series. Though it's set in the 1940s, you'll spot folks you know among the colorful characters: smart-mouth Doris (Rosie O'Donnell), man-magnet Mae (Madonna), insecure Kit (Lori Petty), or sensitive Evelyn (Bitty Schram), who finds out the hard way that "There's no crying in baseball."

THE LINCOLN LAWYER

(2011)

At first glance, defense attorney Mickey Haller (played to perfection by Matthew McCo-
naughey) seems like a greedy, egotistical ambulance chaser. Cruising around LA in
his Lincoln Town Car sporting the vanity plate NTGUILTY, pocketing cash from criminals
to keep them out of prison, Mickey is kind of a weasel. What we learn as the movie
progresses—especially after we meet Mickey's ex-wife (Marisa Tomei) and daughter
(Mackenzie Aladjem)—is that this weasel has a moral code. When a murderer and his
wealthy family try to skirt the law, Mickey fights back, risking everything to ensure that
justice is served in this adaptation of Michael Connelly's novel. Nobody appreciates
sudden attacks of conscience like a Libra. Scales will applaud Haller's ethics and his
courtroom skills.

ABOVE: Matthew McConaughey fights for justice in *The Lincoln Lawyer*. OPPOSITE: *A League of
Their Own*: Libra teamwork wins the game.

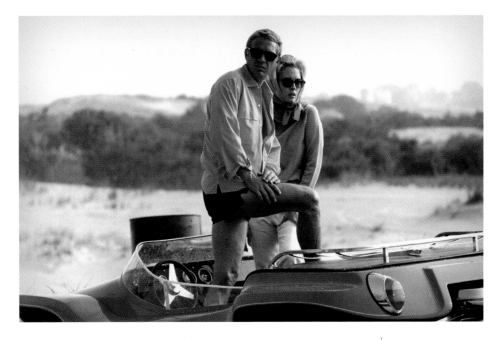

Libra Date Movies

THE THOMAS CROWN AFFAIR
(1968)

The surest way to ruin a date with a Libra is to screen a graphically violent, raunchy, or just plain ugly movie. Scales must be seduced with grace and elegance. Norman Jewison's *The Thomas Crown Affair* is a glossy Libran caper that critic Charles Champlin called "an exercise in beguilement, glamour, and sophistication." As millionaire playboy Thomas Crown, sizzling Steve McQueen meets his match in cool-as-ice Faye Dunaway as a sharp investigator who tries to nail Crown for robbing a bank. At one hour and ten minutes into the film, the grand seduction takes place: The two stars share an artsy montage of unspoken implications and lingering glances over a meaningful game of chess. It's a luxurious slice of sensuality. Plus, sartorial scales will swoon over Dunaway's designer hats, suits, and dresses by Theadora Van Runkle. They don't make movies this chic anymore.

SHAKESPEARE IN LOVE
(1998)

Has it been a while since you've watched this witty and wildly romantic Best Picture Oscar-winner, Libra? If so, it's ripe for rediscovery. It's the late sixteenth century, and young Will Shakespeare (Joseph Fiennes) struggles with his latest play, *Romeo and Ethel, the Pirate's Daughter*. Enter Libra-born actress Gwyneth Paltrow as the bewitching Viola de Lesseps, an early champion for women's rights who disguises herself as a man so she can perform onstage. "I will have poetry in my life," Viola declares, "and adventure, and love. Love above all." Once Will learns Viola's true identity, these two souls become inseparable. Taking rom-com liberties as it recounts the birth of *Romeo and Juliet*—and adding a contemporary spin on the subject—*Shakespeare in Love* is guaranteed to win the heart of your favorite Libran.

Gwyneth Paltrow and Joseph Fiennes in *Shakespeare in Love*. OPPOSITE: A very stylish affair: Steve McQueen and Faye Dunaway in *The Thomas Crown Affair*.

Libra Comedies

CLUELESS
(1995)

Those born under Libra can't be expected to hold society's weightiest problems on their shoulders 24/7. Sometimes, they need a movie that wallows in the lighter side of Libra: parties, dates, makeovers, and shopping. Amy Heckerling's iconic '90s comedy cleverly poses as an ode to outward appearances, but it's really about finding oneself through relationships with others. Easy-on-the-eyes Alicia Silverstone (a Libra) turns in an impeccable comic performance as Cher Horowitz, a Beverly Hills princess who plays matchmaker for everyone except herself. Her epiphany comes when she realizes that she's totally in love with her ex-stepbrother (Paul Rudd). Well, duh! Also worth watching is *Emma* (1996), a more faithful adaptation of the Jane Austen novel that inspired *Clueless*.

BLADES OF GLORY

(2007)

Looking for a laughable Libran bromance? It doesn't get more bromantic than this sports spoof about two rival athletes who form a hilarious partnership. Will Ferrell's Chazz Michael Michaels is a rock-star figure skater from the wrong side of the tracks who serves "a tsunami of swagger" on the ice. Jon Heder's Jimmy MacElroy is a boy wonder whose voice-mail greeting emphatically states, "If you can dream it, you can do it!" Both guys are selfish and vain (Chazz's prized possession is a hairbrush), but when forced to skate together as the first ever same-sex Olympic pairs team, they forge an unlikely friendship. Featuring lots of men in sparkly spandex, *Blades of Glory* grabs the gold medal for sheer ridiculousness. But, at its heart, it's about two vastly different people finding common ground.

Jon Heder, Scott Hamilton, and Will Ferrell in *Blades of Glory.* OPPOSITE: Alicia Silverstone and Stacey Dash in *Clueless* express the lighter side of Libra.

Balanced Libra Classics

IT HAPPENED ONE NIGHT
(1934)

Often called the prototypical romantic comedy, Frank Capra's *It Happened One Night* is sure to strike a chord with scales. Not only is it a gloriously polished black-and-white bonbon from Hollywood's bygone days, but its lead actor and actress, Clark Gable and Claudette Colbert—both big stars—get equal screen time, dialogue, and backstories. When pampered heiress Ellie Andrews (Colbert) and out-of-work newspaper man Peter Warne (Gable) first meet on a bus, they loathe each other. Then, gradually, these opposites attract, falling hopelessly in love as they strike a balance between their extreme differences. From a shirtless Gable to Colbert delicately raising her skirt to expose her leg, the sex here is suggested with subtlety. Libra-approved entertainment for all ages.

THE DEFIANT ONES

(1958)

Libra-born director Stanley Kramer was known for infusing his movies with humanitarian messages. Today, his reputation lives on in the Stanley Kramer Award, given annually to those who use the medium of film to tackle important social issues. One of Kramer's greatest achievements is *The Defiant Ones*. Costars Sidney Poitier and Tony Curtis are exceptional as two escaped convicts—one African American, one Caucasian—literally chained to each other. Made before the era of political correctness, this gripping drama was lauded in its day for addressing racism openly and directly, and with relentless intensity. It was Poitier's first starring role and his first Oscar nomination (for Best Actor; Curtis earned a nod, too). Besides their concern for social issues, Librans gravitate to stories that hinge on cooperation and mutual respect. This one is an especially fine example.

Sidney Poitier and Tony Curtis in *The Defiant Ones*. OPPOSITE: In *It Happened One Night*, Clark Gable and Claudette Colbert prove that opposites attract.

Continued Viewing for Libra

PRIVATE LIVES (1931)

DINNER AT EIGHT (1933)

SULLIVAN'S TRAVELS (1941)

ONE TOUCH OF VENUS (1948)

THE IMPORTANCE OF BEING EARNEST (1952)

SEVEN BRIDES FOR SEVEN BROTHERS (1954)

PATHS OF GLORY (1957)

LET IT BE (1970)

GOOD WILL HUNTING (1997)

LEGALLY BLONDE (2001)

MISS PETTIGREW LIVES FOR A DAY (2008)

PITCH PERFECT (2012)

LES MISÉRABLES (2012)

THE GREAT BEAUTY (2013)

CALL ME BY YOUR NAME (2017)

ASTRO-INFO

Since this sign is all about pairing up, marriages between Librans are not uncommon. Michael Douglas and Catherine Zeta-Jones, Tim Robbins and Susan Sarandon, Naomi Watts and Liev Schreiber, and Paul Simon and Carrie Fisher are some Libra-Libra couples who have been in the public eye.

PARTNERING UP WITH
LIBRA

*Wondering what to pick if you're watching with a movie buddy or significant other?
Wonder no more!*

LIBRA AND ARIES
On the Waterfront
(1954)

*Aries Marlon Brando gives what many
consider the best performance of his
career as Terry Malloy, a longshoreman
and ex-fighter with the nagging social
conscience of a Libra.*

LIBRA AND GEMINI
(500) Days of Summer
(2009)

*At last, a romantic comedy for the intelli-
gentsia. Perceptive dialogue (and a cool
soundtrack) permeates this quirky tale of
a heartbroken greeting-card writer.*

LIBRA AND TAURUS
Snow White and the Seven Dwarfs
(1937)

*Who's the fairest of them all? Scales and
bulls can debate this point as they soak
up the gorgeous animation of Disney's
first feature-length film.*

LIBRA AND CANCER
Blinded by the Light
(2019)

*In this uplifting true story, the socially con-
scious music of Libra singer/songwriter
Bruce Springsteen rocks the world of a
misunderstood teen (Viveik Kalra) while
inspiring him to appreciate his family.*

LIBRA AND LEO
Twentieth Century
(1934)

*After acting in movies for ten years, Libra beauty Carole
Lombard shot to superstardom playing a drama-queen
actress in this love-hate comedy, costarring John Barry-
more as Lombard's despicable Svengali.*

LIBRA AND VIRGO
Phoenix
(2015)

Scales and virgins will absorb this twisty-turny German thriller about a concentration camp survivor. It's rich in psychological subtext, but mainly concerns betrayal in a relationship.

LIBRA AND SCORPIO
The War of the Roses
(1989)

Scorpio Danny DeVito directs Libra Michael Douglas in this tale of a perfect marriage gone horribly wrong. Kathleen Turner won a Golden Globe for her tragicomic performance as Douglas's wife.

LIBRA AND SAGITTARIUS
Contempt
(1963)

Libran "sex kitten" Brigitte Bardot is directed by Sagittarian auteur Jean-Luc Godard in this captivating French New Wave drama.

LIBRA AND CAPRICORN
The Master
(2012)

This dark period piece, costarring Philip Seymour Hoffman and Joaquin Phoenix, examines power dynamics (Capricorn) in a close relationship (Libra).

LIBRA AND AQUARIUS
Gandhi
(1982)

Since scales and water-bearers are into doing good on a grand scale, both will groove to this epic enactment of peaceful Libra-born leader Mahatma Gandhi's life.

LIBRA AND PISCES
Moonrise Kingdom
(2012)

Quaint, romantic, and unapologetically sentimental, Wes Anderson's ode to first love is pure poetry—set on an island. What more could amorous Libra and poetic Pisces want?

See also the eleven other "Partnering Up" sections for more sign-compatible recommendations.

LIBRA STARS

JULIE ANDREWS
(October 1)

HUGH JACKMAN
(October 12)

BRIGITTE BARDOT
(September 28)

BRIE LARSON
(October 1)

MONTGOMERY CLIFT
(October 17)

CAROLE LOMBARD
(October 6)

MATT DAMON
(October 8)

GWYNETH PALTROW
(September 27)

MICHAEL DOUGLAS
(September 25)

TIM ROBBINS
(October 16)

ZAC EFRON
(October 18)

SUSAN SARANDON
(October 4)

CARRIE FISHER
(October 21)

WILL SMITH
(September 25)

MARK HAMILL
(September 25)

SIGOURNEY WEAVER
(October 8)

RITA HAYWORTH
(October 17)

KATE WINSLET
(October 5)

CHARLTON HESTON
(October 4)

CATHERINE ZETA-JONES
(September 25)

♏

SCORPIO

OCTOBER 23–NOVEMBER 21

♇

SCORPIO THE SCORPION IS A WATER SIGN, AND THIS STILL WATER

runs deep. Governed by Pluto, the planet (or don't call it a planet if you prefer; it's all the same to Pluto) of death and soul transformation, Scorpios are drawn to the dark side. Mystery, tragedy, and secrets compel them. They often seem driven by powerful emotions and instincts that others don't easily understand. Because of all this gloom and doom, they've gotten a bad rap. The truth is, those born under Scorpio are emotionally sensitive and easily wounded, and when they feel hurt, they strike back—watch the sting of that scorpion tail! They've been known to defend themselves with sharp words, manipulative tactics, and power trips. Yet there is a softer side hidden behind the exoskeleton: their deep capacity for love. The evolved, mature Scorpio soul can be a pas-

sionate force for good in the universe because when they care, they *really, really* care. When it comes to entertainment, their tastes run predictably dark. Not every scorpion is a horror fanatic, but let's just say they can handle intense movies that others shy away from. Scorpios enjoy exploring the sinister underbelly of life. Especially from the safety of a comfy Cineplex seat.

If you're a Scorpio, you're likely fascinated by gangster pictures, film noir, or anything related to the criminal underworld—think *The Godfather* (1972), *Scarface* (1983), and *The Untouchables* (1987). With your insight and determination to get to the bottom of things, you would make a great investigator. In *The Changeling* (1980), George C. Scott's character literally gets to the bottom of a haunted house

Deadly Scorpio humor on display in *Death Becomes Her.* OPPOSITE: Scorpio Jodie Foster descends into the dark side in *The Silence of the Lambs.*

135

by digging into the dank, dismal pit of a subterranean burial site. *The Silence of the Lambs* (1991) similarly features an investigator (Jodie Foster) descending into a dark dungeon to destroy a monster.

When Scorps are not engulfed by macabre moods, they love to sink their stingers into a good comedy—especially one with a bite, like the vampire romance *Love at First Bite* (1979). Also bound to make scorpions smile are the creepy, edgy *Addams Family* (1991), the morbid farce *Death Becomes Her* (1992), and the pitch-black humor of *Deadpool* (2016). When it comes to superheroes, though, the brooding, secretive Batman is the most typically Scorpio of them all, particularly in Christopher Nolan's *Dark Knight* movies (2005–2012).

Oh, yeah. Did I fail to mention that Scorpio is the sex god/goddess of the zodiac? Because Pluto is associated with sex as well as death, scorpions have strong desires, and irresistible animal magnetism. Female Scorps can be especially intimidating, and are best symbolized on the screen by those seductive, dangerous femme fatales like Lana Turner in *The Postman Always Rings Twice* (1946), Scorpio Dorothy Dandridge in *Carmen Jones* (1954), or the smoldering Kathleen Turner in *Body Heat* (1981). On the more romantic side, in *Laura* (1944), a detective (Dana Andrews) "falls in love with a corpse," to quote a line from the film. As the titular Laura, Gene Tierney (another Scorpio) bewitches as a murdered beauty who may not be quite so dead, after all. For a truly sadistic lady scorpion character, see Scorpio-born knockout Hedy Lamarr in the neglected noir *The Strange Woman* (1946).

How is all that Scorpio passion and power expressed creatively? In addition to the recommendations that follow, check out the films of Scorpio-born directors Michael Crichton, Jodie Foster, Peter Jackson, Ang Lee, Garry Marshall, Sam Raimi, Harold Ramis, Mike Nichols, Martin Scorsese, and Luchino Visconti. The piercing insight and intensity characteristic of the sign of the scorpion can be observed in their work.

OPPOSITE: **Martin Scorsese directs Robert De Niro in** *Taxi Driver*.

ASTRO-INFO

· · · ✳ · · ·

When it comes to Scorpios in Hollywood, enduring filmmaking force Martin Scorsese exemplifies the Pluto-ruled. His gritty, crime-drenched films (*Mean Streets* [1973], *Taxi Driver* [1976], *Casino* [1995], etc.) helped to transform the entire industry, and his near-obsessive passion for movies is legendary. In the 1970s, Scorsese advertised his astrological sign by wearing a scorpion medallion around his neck.

Seriously Scorpio Cinema

L.A. CONFIDENTIAL
(1997)

The seediest scandals festering beneath the glitz of Hollywood are exposed in Curtis Hanson's nifty-'50s neo-noir. "You'd think this place was the Garden of Eden," Danny DeVito's character says of LA in his tongue-in-cheek narration, "but there's trouble in paradise." The trouble brews when a trio of cops who can't stand each other—ambitious Ed Exley (Guy Pearce), volatile Bud White (Russell Crowe), and self-serving Jack Vincennes (Kevin Spacey)—team up to uncover a bloody trail of corruption that leads right back to the LAPD. *L.A. Confidential* is sordid and unsanitized, yet sparkling with midcentury sheen and radiating a redemptive message about rooting out wrongdoing, even when it's easier to leave it buried. Kim Basinger snared an Oscar for her role as a glamorous prostitute (modeled after Scorpio Veronica Lake) in this salacious stew of sinful behavior. It's all very Scorpio.

138

DRIVE
(2011)

In this stylish action-thriller, Ryan Gosling's stunt driver doesn't talk much. Remaining nameless and enigmatic with his powerful emotions cloaked, he lets his actions speak for him. One clue to the Driver's inner self is embroidered on the back of his satin jacket: a scorpion. Since Gosling himself is a Scorpio, it's tempting to interpret his character as a typical Scorp; driven by his own moral code and strong passions, he gets himself tangled in a web of trouble, almost to the point of self-destruction. Gritty and violent, yet strangely hypnotic, *Drive* features a slick electronic score by Cliff Martinez and stellar performances by Carey Mulligan, Bryan Cranston, Christina Hendricks, and Albert Brooks.

In *Drive*, **Scorpio Ryan Gosling stays true to his sign.** OPPOSITE: **Kim Basinger** in *L.A. Confidential.*

Scorpio Date Movies

TITANIC

(1997)

Looking to score with a Scorp? Your best bet is a flick about a forbidden love that endures beyond death: a little thing called *Titanic*. Scorpio star Leonardo DiCaprio exhibits the devil-may-care charisma typical of his sign as freewheeling artist Jack Dawson, a third-class passenger who falls head over heels for first-class belle Rose (Kate Winslet) aboard the infamous RMS *Titanic* in 1912. Though Jack and Rose don't know each other for long, DiCaprio and Winslet (and writer/director James Cameron) convince us that their frowned-upon feelings are pure, that they are destined for each other. Even icebergs can't destroy their ocean of romance. By tapping into our deep-seated desire for eternal love, this epic became the first movie to earn a billion dollars at the box office. The heart does indeed go on.

Eternal love in *Titanic*: Kate Winslet and Leonardo DiCaprio. OPPOSITE: Medium Oda Mae (Whoopi Goldberg) channels the spirit of Sam (Patrick Swayze) in *Ghost*.

GHOST

(1990)

For the Scorpio-born, love stories tend to have more impact when death is involved. In this contemporary classic, scorpion actresses Demi Moore and Whoopi Goldberg join forces (for Team Scorpio) as they solve a murder with the help of a ghost. Moore is Molly, the girlfriend of recently slain Sam (Patrick Swayze), and Goldberg earned a Best Supporting Actress Oscar for playing the outlandish Oda Mae, a phony psychic who becomes legit when visited by Sam's spirit. With its unlikely mix of romance, supernatural drama, and comedy that Demi herself called "a recipe for disaster," *Ghost* miraculously worked, becoming audiences' most beloved movie of 1990. "It's amazing, Molly," Sam says of dying. "The love inside—you take it with you." The genuine feeling at the heart of the story continues to resonate today. Especially with Scorps.

Scorpio Comedies

WHAT WE DO IN THE SHADOWS
(2014)

Scorpio, you have a wicked sense of humor. Slightly twisted, perverse comedy reso-
nates to the tip of your tail. The next time you need a chuckle, check out *What We Do
in the Shadows*, the demented documentary that dares to explore the trials and tribula-
tions of modern-day vampire life in suburban New Zealand. Centuries-old roommates
Viago (Taika Waititi), Vladislav (Jemaine Clement), and Deacon (Jonathan Brugh) may
live in coffins, suck the blood of humans, and soar through the night like bats, but they
still argue over whose turn it is to wash the dishes. Gathering all the pop culture tropes
about vampirism and reinterpreting them with a wink, this satire (written and directed by
Waititi and Clement) inspired a 2019 TV series as well.

BEETLEJUICE

(1988)

He snacks on flies. He "had a pretty good time" during the Black Plague. He's Betel-geuse—the ghost with the most, babe. But Michael Keaton's diabolically funny turn as the "bio-exorcist" is just one of the dark delights in Tim Burton's one-of-a-kind master-piece about the comical conflicts between the living and the dead, namely Geena Davis and Alec Baldwin as a recently deceased couple and Winona Ryder as the emo teen who yearns to join them. Against a backdrop of production designer Bo Welch's utterly unique aesthetic, Burton presents an afterlife rife with jokes about death—not to men-tion a calypso-flavored possession that must be seen to be believed. If you're a Scorpio and you've never seen *Beetlejuice*, stop reading and watch it this instant.

Michael Keaton and Winona Ryder in *Beetlejuice*. OPPOSITE: Vampirism is played for laughs in *What We Do in the Shadows*.

Seductive Scorpio Classics

TO CATCH A THIEF
(1955)

Scorpio ladies are hot stuff. Case in point: Grace Kelly, the movie-star-turned-princess who was director Alfred Hitchcock's favorite blonde in the 1950s. In the scintillating romantic romp *To Catch a Thief*, Hitchcock and screenwriter John Michael Hayes cast her as Frances, a wealthy tourist with a passion for danger—and a yen for dapper ex– cat burglar John Robie (Cary Grant). Hitch and Hayes even wrote the part especially for Grace. Scorps will soak up the sun-drenched, sexy setting of the French Riviera, not to mention the fireworks between the two glamorous costars. Fun fact: Grace Kelly was so into honoring her much-maligned sun sign that she held a lavish Scorpio-themed party to celebrate her fortieth birthday in 1969. Only Scorpios were invited.

CHINATOWN

(1974)

Roman Polanski's atmospheric noir, set in 1930s Los Angeles, is woven with subtle Scorpio themes. As jaded private eye Jake Gittes, Jack Nicholson must wade through a swamp of secrets and lies to uncover the truth about the enigmatic Evelyn Mulwray (Faye Dunaway) and her husband, Hollis, a water-department executive. Tantalized into an affair with Evelyn and injured by corporate henchmen, Jake sinks ever more deeply into danger as he strives in vain to solve an impossible mystery and prevent a tragic outcome. "You get tough. You get tender. You get close to each other. Maybe you even get close to the truth," proclaimed the poster for the Oscar-winning *Chinatown*. And guess what the story is all about? Water. Literally. As water signs, Scorps are sure to be quenched.

Jake Gittes (Jack Nicholson) is snared in a web of intrigue in *Chinatown*. OPPOSITE: A classic Scorpio seduction: Grace Kelly and Cary Grant in *To Catch a Thief*.

Continued Viewing for Scorpio

THE LOCKET (1946)

NIGHTMARE ALLEY (1947)

THE SEVENTH SEAL (1957)

DEATH ON THE NILE (1978)

DIRTY ROTTEN SCOUNDRELS (1988)

SEX, LIES AND VIDEOTAPE (1989)

I LOVE YOU TO DEATH (1990)

SE7EN (1995)

THE WINGS OF THE DOVE (1997)

WHAT DREAMS MAY COME (1998)

EYES WIDE SHUT (1999)

DONNIE DARKO (2001)

ZODIAC (2007)

THE LOVELY BONES (2009)

THE DESCENDANTS (2011)

⇒ SCORPIO HIDDEN GEM ⇐

Searching for a hidden treasure, Scorpio? Try the 1943 mystery *The 7th Victim*, produced by horror pioneer Val Lewton. The movie's themes of psychological terrorism, witchcraft, and suicide were rarely explored in the 1940s, and they set the stage for later landmarks, such as *Rosemary's Baby* (1968).

PARTNERING UP WITH
SCORPIO

Wondering what to pick if you're watching with a movie buddy or significant other? Wonder no more!

SCORPIO AND ARIES
Goodfellas
(1990)

Martin Scorsese's slick sonnet to gangsters is funny and fast-moving for Aries, while also violent and threatening for the Scorps.

SCORPIO AND GEMINI
I Married a Witch
(1942)

In this frothy comedy, Scorpio temptress Veronica Lake plays a sinister little witch who accidentally swallows her own love potion and goes gaga for a man she loathes.

SCORPIO AND TAURUS
Dr. Strangelove
(1964)

Total Taurean reality meets deep, dark Scorpio-esque fantasy in Stanley Kubrick's scathingly funny nuclear disaster satire.

SCORPIO AND CANCER
Sleepless in Seattle
(1993)

Scorp Meg Ryan's first teaming with Cancer costar Tom Hanks has plenty of warmth and romantic sparks to please both crabs and scorpions.

SCORPIO AND LEO
Once Upon a Time . . . in Hollywood
(2019)

Quentin Tarantino's love letter to 1960s Hollywood has the showbiz allure lions love against the grisly backdrop of the Charles Manson murders.

SCORPIO AND VIRGO
Black Swan
(2010)

This visually striking story of a disciplined ballerina who slips over the edge of sanity is perfect Scorpio-Virgo viewing. Psychological terror never looked so beautiful.

SCORPIO AND CAPRICORN
Seconds
(1966)

John Frankenheimer directs Scorpio Rock Hudson as a middle-aged man who gets a serious surgical makeover. A dire cautionary tale for goats and scorpions who want it all.

SCORPIO AND LIBRA
My Best Friend's Wedding
(1997)

Scorpio leading lady Julia Roberts pulls a slew of nasty tricks to sabotage her guy-best-friend's nuptials. But it's all done in the name of love, so Libra approves.

SCORPIO AND AQUARIUS
Ex Machina
(2014)

Tomorrow's technology takes the form of a lovely female enchantress in this foreboding thriller about the dark side of artificial intelligence.

SCORPIO AND SAGITTARIUS
The Godfather: Part II
(1974)

This acclaimed sequel expands on the crime-family drama, focusing on the young Vito Corleone in Sicily. Plenty of Scorpion grit and Sagittarian scope.

SCORPIO AND PISCES
Overboard
(1987)

Watch Goldie Hawn (a Scorpio) and real-life romantic partner Kurt Russell (a Pisces) tussle when he misleads her amnesiac character into believing she's his wife.

See also the eleven other "Partnering Up" sections for more sign-compatible recommendations.

SCORPIO STARS

LEONARDO DICAPRIO
(November 11)

BURT LANCASTER
(November 12)

SALLY FIELD
(November 6)

VIVIEN LEIGH
(November 5)

JODIE FOSTER
(November 19)

MATTHEW MCCONAUGHEY
(November 4)

WHOOPI GOLDBERG
(November 13)

DEMI MOORE
(November 11)

RYAN GOSLING
(November 12)

RYAN REYNOLDS
(October 23)

ANNE HATHAWAY
(November 12)

JULIA ROBERTS
(October 28)

ETHAN HAWKE
(November 6)

MEG RYAN
(November 19)

GOLDIE HAWN
(November 21)

WINONA RYDER
(October 29)

GRACE KELLY
(November 12)

EMMA STONE
(November 6)

VERONICA LAKE
(November 14)

GENE TIERNEY
(November 19)

SAGITTARIUS

NOVEMBER 22–DECEMBER 21

♃

SAGITTARIUS THE ARCHER IS REPRESENTED BY A CENTAUR, A HALF-

man-half-horse drawing a bow and arrow aimed at the heavens. This image expresses the typical Sag personality: They're ready to gallop into the great wide open, focused on new horizons and unconquered lands. Ruled by Jupiter—the planet of expansion, good fortune, and big ideas—natives of this ebullient fire sign have a way of turning a gloomy sky into bright sunshine.

Lighthearted and optimistic, Sagittarius couldn't be more different from its intense next-door neighbor, Scorpio. Armed with sky-high hopes, a hunger for learning, and an inexhaustible sense of humor, Sag tackles life with both hands and never says no. Whether it's hopping a plane to an exotic country or taking a spontaneous weekend road trip, archers love to travel but hate to make rigid plans. With benevolent Jupiter in their corner, Sagittarians don't need to plan—they can simply coast on their good luck. Their downfall is living large to the point of recklessness (as in gambling big and losing big); their most admirable trait is truth-seeking. Sag is the seeker and wanderer

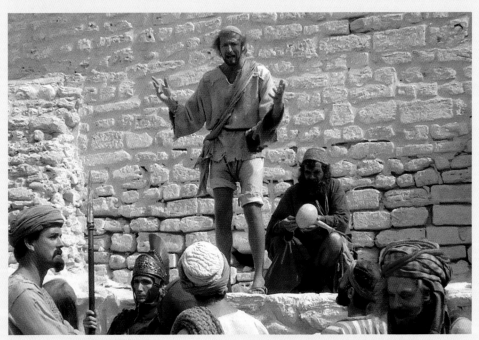

Graham Chapman has a difficult time as the Messiah in *Monty Python's Life of Brian*. OPPOSITE: Harrison Ford as adventure hero Indiana Jones.

152

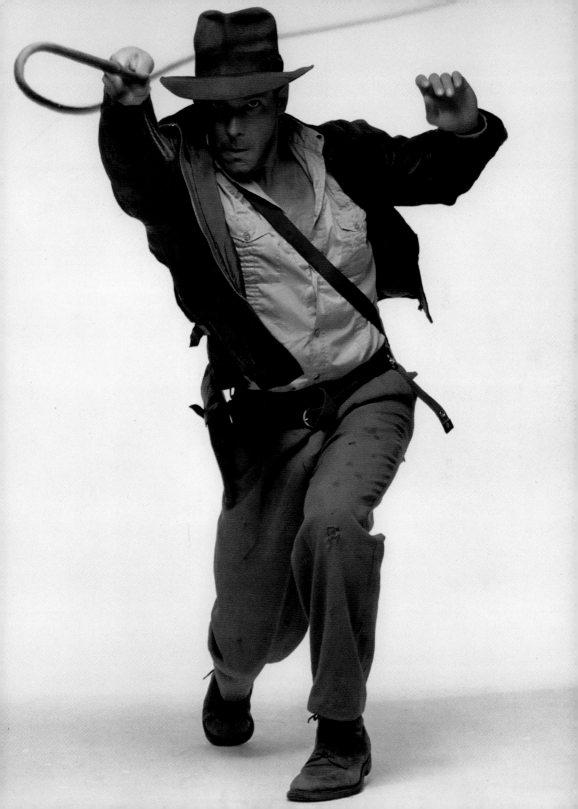

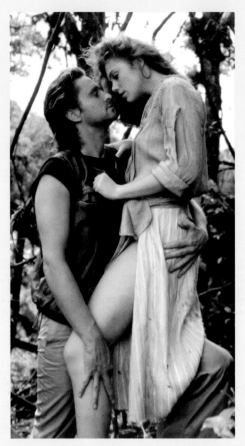

Michael Douglas and Kathleen Turner exude Sagittarian sex appeal in *Romancing the Stone*.

of the zodiac. But when Sags finally settle down in one place, they make every day an adventure for those they love.

Sagittarius, if you can ever stay in one place long enough to watch an entire feature film, you probably enjoy international cinema—or even just movies that take you on a visual journey. Road-trip tales like John Hughes's memorable '80s excursion *Planes, Trains & Automobiles* (1987), the cultural memoir *The Motorcycle Diaries* (2004), and the transgender travelogue *Transamerica* (2005) provide a scenic getaway without having to leave the couch.

Archers thirst for adventure. Case in point: Sag Steven Spielberg, who built his early reputation on action-filled jaunts such as *The Sugarland Express* (1974), *Raiders of the Lost Ark* (1981), and *The Goonies* (1985), plus all the *Indiana Jones* sequels and the *Jurassic Park* franchise. If you're hankering to delve even more deeply into the classic adventure genre, Clark Gable and Jean Harlow in *China Seas* (1935), Errol Flynn in *The Adventures of Robin Hood* (1939), and James Mason and Kirk Douglas in *20,000 Leagues Under the Sea* (1954) are solid places to start.

When it comes to spirituality, Sagittarians have been known to try out different religions or belief systems until they find one that fits. To get your sacred cinematic fix, Sag, try the inspiring *Eat Pray Love* (2010), Ang Lee's stunning *Life of Pi* (2012), or the offbeat religious-themed comedy *Monty Python's Life of Brian* (1979). For a more sober exploration of organized religion, follow Audrey Hepburn as she takes her vows and travels to Africa in Fred Zinnemann's beautifully shot *The Nun's Story* (1959).

Sagittarius-born filmmakers excel at creating worlds that never before existed, and tempting audiences to experience these vibrant new realms. In addition to the recommendations that follow, try observing that signature Sag style in the films of directors Woody Allen, Kenneth Branagh, Joel Coen, Alfonso Cuarón, Terry Gilliam, Jean-Luc Godard, Rian Johnson, Fritz Lang, Nancy Meyers, Otto Preminger, Ridley Scott, Susan Seidelman, Penelope Spheeris, Steven Spielberg, and Julie Taymor.

ASTRO-INFO

Lady archers seem to have the guts and chutzpah necessary to make it as directors in the boys' club of Hollywood. Just look at Nancy Meyers, Penelope Spheeris, Susan Seidelman, and Julie Taymor.

Susan Seidelman, a Sagittarius, directs Madonna in *Desperately Seeking Susan*, 1985.

Sensational Sagittarius Screenings

ALADDIN
(2019)

Walt Disney himself was born under the sign of the centaur (on December 5), and he would no doubt be thrilled at his studio's latest sweeping, splashy musical version of the ancient Arabian tale about a penniless street urchin and his magic lamp. Like a typical Sag, Aladdin (Mena Massoud) lives moment to moment by his wits, traveling light (a monkey is his only carry-on), and staying "one trick ahead of disaster" with a winning smile and a dose of good luck. And what could be luckier than having a giant blue genie (Will Smith) as your BFF? With his three wishes, Aladdin rides a magic carpet to a whole new world with his dream girl, the plucky Princess Jasmine (Naomi Scott)—and helps make others happy in the process. It's the ultimate Sagittarian fantasy.

BIG FISH
(2003)

Archers are prone to exaggeration. Not because they are dishonest, but because they naturally embellish reality into something bigger and better than it actually is. In Tim Burton's warm and wise *Big Fish*, the life story of one man (Edward Bloom, played by Albert Finney and Ewan McGregor) is told as a mythical odyssey of mammoth proportions. Edward's son, Will (Billy Crudup), is tired of hearing his dad's tall tales, or "amusing lies," as he calls them. With Edward bedridden and nearing the end of his life, Will flashes back to the fanciful yarns of his father's youth, trying to piece together the truth. But the truth, according to Edward, is simply "all the facts, none of the flavor." And where's the fun in that? Spoiler: Edward's exaggerations stand triumphant in the end.

OPPOSITE: In *Big Fish*, Alison Lohman and Ewan McGregor experience an exaggerated romantic fantasy.

Sagittarius Date Movies

A VERY LONG ENGAGEMENT
(2004)

How do you get a roaming Sagittarius to sit still for a two-hour-and-thirteen-minute romantic drama? By making it engrossing, quick-moving, and rich in detail, like Jean-Pierre Jeunet's French-language epic concerning Mathilde (Audrey Tatou), a young lady pining for her fiancé, Manech (Gaspard Ulliel), who may or may not have survived World War I. Despite being slowed by a limp (from childhood polio), Mathilde treks across France searching for clues to Manech's whereabouts. Gradually, the various threads of the story are woven into a textured tapestry of light and dark, hope and discouragement, whimsy and passion. Aline Bonetto's sterling art direction provides eye candy, and Jodie Foster provides a nice surprise when she appears in a cameo role. Perfect for cuddling up with an archer.

ROMANCING THE STONE
(1984)

In this spicy Sagittarian adventure-comedy from Robert Zemeckis, uptight novelist Joan Wilder (Kathleen Turner) loses her luggage, her shoe heels, and her inhibitions when she embarks on an exhilarating quest for buried treasure in Colombia with charming rascal Jack T. Colton (Michael Douglas). But when they uncover the legendary El Corazón emerald, can Joan trust Jack not to swipe the jewel and run? With humor, thrills, and a refreshing aversion to rom-com clichés, Zemeckis (aided by producer Douglas and a droll script by Diane Thomas) delivers a genuinely exciting romance. Shooting on location gave the cast and crew a few adventures of their own; rainstorms, mudslides, jungle insects, and alligator attacks plagued the *Romancing* company during their stay in Mexico. But the result will romance your significant centaur.

OPPOSITE: Audrey Tautou travels across France in *A Very Long Engagement*.

Sagittarius Comedies

THE BIG LEBOWSKI
(1998)

Even the title of this outrageous cult favorite has a Jupiterian ring to it. The tone is cock-eyed, confused, and large on laughs when Sag Jeff Bridges lets his hair down as The Dude, a laid-back (read: lazy), unemployed bowling enthusiast who stumbles into a web of intrigue in Los Angeles. Cowriter and director Joel Coen was also born under the sign of Sagittarius (his brother and collaborator, Ethan Coen, is a Virgo), and he pulls out all the stops, infusing this fantastical comedy-mystery with Busby Berkeley–inspired dance numbers and musical dream sequences. With his two bowling buddies (John Goodman and Steve Buscemi) and his special lady friend, Maude (Julianne Moore), by his side, The Dude slips into a giddy noir-ish netherworld that *USA Today* once dubbed "L.A. Inconsequential." No negative energy here, man.

Sagittarius Jeff Bridges (here with Julianne Moore) rolls a strike as Jeff Lebowski.

PIRATES OF THE CARIBBEAN:
THE CURSE OF THE BLACK PEARL
(2003)

As Cancers love to escape to the past, Sagittarians dig movies about escaping to other places. The first *Pirates* installment in the franchise is all about escape—to exotic locales as well as to another, simpler age (the early eighteenth century). You may recall the tattered pirate flags of the Black Pearl, the vast blue waters of the Caribbean Sea, and the cave packed with gold Aztec treasure, but if you haven't seen Gore Verbinksi's *Curse of the Black Pearl* in a while, you may have forgotten just how hilarious it is. Between Ted Elliott and Terry Russio's clever script awash in pirate parody ("Aye! Avast!") and Johnny Depp's eccentric Oscar-nominated characterization of Captain Jack Sparrow (the worst pirate you've ever heard of), this seafaring adventure is good for a million giggles.

ABOVE: Johnny Depp, Keira Knightley, and Orlando Bloom escape the everyday in *Pirates of the Caribbean*.

Scenic Sagittarius Classics

KING KONG
(1933)

Sagittarians do everything on a grand scale. When it comes to leading men, no one in Hollywood history looms grander than the fifteen-ton, twenty-foot-tall ape that scales the Empire State Building to impress his human crush, the lovely Ann Darrow (Fay Wray). Preceding that final iconic scene is an hour and a half of pulse-pounding adventure as a film crew, headed by director Carl Denham (Robert Armstrong), travels to the uncharted Skull Island to shoot a wildlife movie. But life gets wilder than they bargained for when Ann is kidnapped and served as a snack to Kong, a god to the island natives. Throw in some dinosaurs, giant snakes, a skyscraper, and airplanes, and it all adds up to a very sizable saga.

THE HARVEY GIRLS
(1946)

Powerhouse talent Judy Garland headlines this soaring historical musical about young women who wander at a time when girls don't typically leave their homes and travel alone—the 1880s. Arriving by train from the Midwest to become waitresses at the new Harvey House restaurant in Sand Rock, Arizona, Judy's Susan and her gal-pals (Cyd Charisse and Virginia O'Brien) bring a touch of class to the Wild West. Featuring pastoral backdrops (outdoor scenes were shot in rural California and Monument Valley, Utah), a sexy young Angela Lansbury, and Judy's spectacular rendition of the Oscar-winning tune "On the Atchison, Topeka and the Santa Fe," *The Harvey Girls* delivers timeless entertainment for archers young and old.

ABOVE: Judy Garland and her fellow travelers journey to the Wild West in *The Harvey Girls*. OPPOSITE: King Kong: the biggest star in Hollywood history?

Continued Viewing for Sagittarius

TARZAN THE APE MAN (1932)

DOWN ARGENTINE WAY (1940)

AROUND THE WORLD IN EIGHTY DAYS (1956)

POLLYANNA (1960)

BANDE À PART (1964)

MONTY PYTHON AND THE HOLY GRAIL (1975)

SILVER STREAK (1976)

A PASSAGE TO INDIA (1984)

THE BEACH (2000)

SPIRITED AWAY (2001)

L'AUBERGE ESPAGNOLE (2003)

INTO THE WILD (2007)

THE DARJEELING LIMITED (2007)

AMERICAN HONEY (2016)

FACES PLACES (2017)

⇛ SAGITTARIUS HIDDEN GEM ⇚

Looking for a different spin on the traditional romantic comedy? Check out the 1994 high-energy slice-of-street-life *I Like It Like That*. Darnell Martin became the first African American woman to direct a studio feature film with her colorful exploration of various romantic possibilities open to a saucy city girl (Lauren Velez).

PARTNERING UP WITH
SAGITTARIUS

Wondering what to pick if you're watching with a movie buddy or significant other? Wonder no more!

SAGITTARIUS AND ARIES
True Romance
(1993)

Aggressively Aries filmmaker Quentin Tarantino cowrote the script for this wild, sexy ride of a movie that zooms from Detroit to Los Angeles in a purple Cadillac.

SAGITTARIUS AND GEMINI
12 Monkeys
(1995)

Experience the Gemini-level brilliance (and insanity) as Sag Brad Pitt is directed by Sag Terry Gilliam in the most off-the-wall performance of his career.

SAGITTARIUS AND TAURUS
On Golden Pond
(1981)

Archer Jane Fonda and bull Katharine Hepburn (joined by Jane's dad, Taurus Henry Fonda) star in this Oscar-winner set at an idyllic lakeside cottage.

SAGITTARIUS AND CANCER
The Tender Trap
(1955)

Swinging Sag superstar Frank Sinatra gets hooked by marriage-minded Debbie Reynolds in this sweetly charming CinemaScope romp.

SAGITTARIUS AND LEO
The Greatest Showman
(2017)

What could be more appealing to showy lions and grandiose archers than a musical spin on the life of circus pioneer P. T. Barnum?

SAGITTARIUS AND VIRGO
The Secret Life of Walter Mitty
(2013)

Ben Stiller (a Sag) directs this adaptation of a James Thurber story, and plays a magazine employee with an imagination that runs away with itself.

SAGITTARIUS AND LIBRA
Annie Hall
(1977)

Woody Allen examines a romantic relationship (Libra's domain) through the prism of his unhinged Sagittarian humor, aided by quirky leading lady Diane Keaton.

SAGITTARIUS AND SCORPIO
Jaws
(1975)

Sagittarian Steven Spielberg made the world terrified to go into the water with the first-ever summer horror blockbuster. Both archers and scorpions will bite this bait.

SAGITTARIUS AND CAPRICORN
Down and Out in Beverly Hills
(1986)

For Caps who get too caught up in status-symbol success—like businessman Dave Whiteman (Richard Dreyfuss)—a lesson from a freewheeling drifter (Nick Nolte) is just the ticket.

SAGITTARIUS AND AQUARIUS
Lucy
(2014)

See Sag sex symbol Scarlett Johansson develop super brain power when she ingests a bizarre mind-altering drug. It's a very Aquarian head trip.

SAGITTARIUS AND PISCES
Cast Away
(2000)

Talk about breaking free from a rut and escaping to a faraway place. Tom Hanks gets more escapism than he wants in this ideal adventure for archers and fish.

See also the eleven other "Partnering Up" sections for more sign-compatible recommendations.

SAGITTARIUS STARS

JEFF BRIDGES
(December 4)

SAMUEL L. JACKSON
(December 21)

JAMIE LEE CURTIS
(November 22)

SCARLETT JOHANSSON
(November 22)

KIRK DOUGLAS
(December 9)

BETTE MIDLER
(December 1)

PATTY DUKE
(December 14)

RITA MORENO
(December 11)

JANE FONDA
(December 21)

BRAD PITT
(December 18)

JAMIE FOXX
(December 13)

RICHARD PRYOR
(December 1)

BETTY GRABLE
(December 18)

FRANK SINATRA
(December 12)

GLORIA GRAHAME
(November 28)

BEN STILLER
(November 30)

JAKE GYLLENHAAL
(December 19)

MARISA TOMEI
(December 4)

DARYL HANNAH
(December 3)

DICK VAN DYKE
(December 13)

CAPRICORN

DECEMBER 22–JANUARY 20

♄

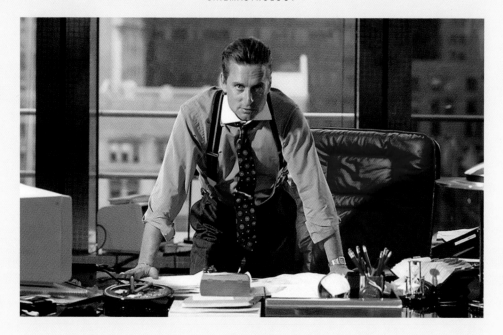

AMBITIOUS, PRACTICAL, AND WITH A DEEP NEED TO ACHIEVE,

those born under the earth sign of Capricorn the goat often accomplish great things. But they don't desire overnight success; goats seek recognition for the fruits of their labors, which may take years to ripen. And they have the patience to wait. Capricorn is governed by Saturn, traditionally the god of time. A chilly planet encircled by rings of ice, Saturn is associated with hard work, maturity, and fatherhood, all of which factor into the goat personality. Caps are the grown-ups of the zodiac: Excelling in a career, shouldering the responsibility of paying the rent, and becoming a parent or authority figure come naturally to them. Always in control—sometimes to the point of seeming unemotional or aloof (picture Capricorn Cary Grant's debonair nonchalance)—goats are typically self-reliant. These winter-solstice babies also possess a dark side; if not as dark as Scorpio's, at least it's a dimly lit side. At the movies, you won't find them whooping it up in the front row but way in the back, quietly taking notes on their favorite films. And plotting to run their own studio someday.

ABOVE: Michael Douglas takes Capricorn ambition to new heights in *Wall Street*. OPPOSITE: Sylvester Stallone (here with Talia Shire) becomes a neighborhood hero in *Rocky*.

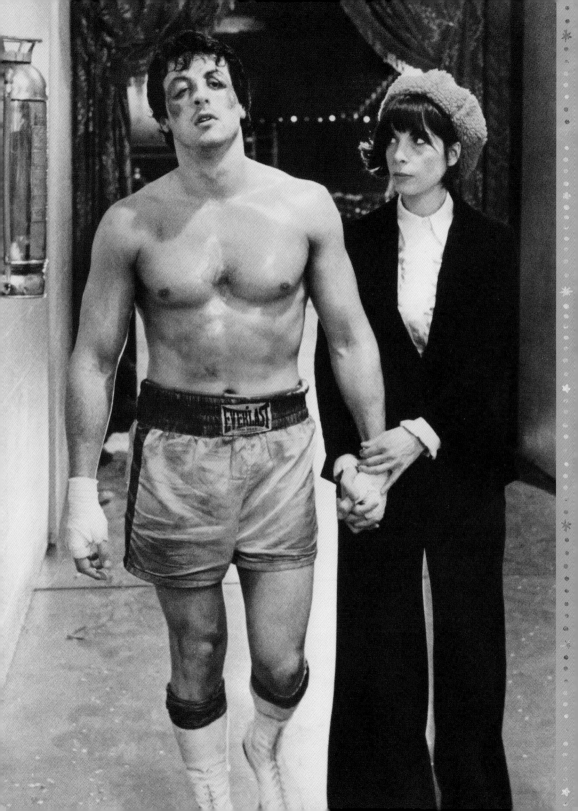

Capricorn Maggie Smith has her authority challenged in *The Prime of Miss Jean Brodie*.

Business aspirations loom large in the Capricorn consciousness. If you're a Cap, you may dream of scaling the ladder of success, like Leonardo DiCaprio's stockbroker in *The Wolf of Wall Street* (2013) or the hungry young Bud Fox (Charlie Sheen) in Oliver Stone's classic *Wall Street* (1987). Goats, for a glimpse of cutthroat office politics in the world of real-estate sales, dig your horns into Capricornian director James Foley's savvy *Glengarry Glen Ross* (1992).

Though the Saturn-ruled have an all-business reputation, they also have a keen sense of humor—sometimes even a zany streak they unleash when the mood strikes. British master of sarcasm Rowan Atkinson is a Capricorn, as is the dryly amusing Jason

Bateman, and the outrageous Jim Carrey. In *Man on the Moon* (1999), Carrey eerily channels fellow Cap comic Andy Kaufman, and the result is funny, poignant, and surreal. Classic-era Capricorn Danny Kaye brought an inspired wackiness to every film he graced.

Endurance is a Capricorn keyword. Just like a real goat hoofing it up a mountain step by step, zodiacal goats set a goal and do not deviate until they reach it. Movies about literal mountain climbing, such as *Touching the Void* (2003) and *Free Solo* (2018), tend to resonate with Caps, as do the *Rocky* films (1976–2018). Rocky Balboa's ascension from small-time boxer to working-class hero of the 'hood is symbolized by his climbing the stone steps at the Philadelphia Museum of Art—a very Capricorn visual.

Movies that explore the dynamics of authority figures and fatherhood fall into the Capricorn domain. In *The Pursuit of Happyness* (2006), sheer determination for a better life keeps a struggling single dad (Will Smith) going, while a conman/father figure (Ryan O'Neal) sets a dubious example for his little girl (Tatum O'Neal) in *Paper Moon* (1973). Authority yields unexpected consequences for Capricorn grande dame Maggie Smith, who schools her students in a few life lessons (and faces some hard lessons herself) in *The Prime of Miss Jean Brodie* (1969).

Thanks to their ability to control, to plan, and to maintain their artistic integrity no matter what, Caps often succeed as filmmakers. In addition to the recommendations that follow, check out the filmographies of Capricorn-born directors Dorothy Arzner, John Carpenter, Gurinder Chadha, Damien Chazelle, Bradley Cooper, Michael Curtiz, Federico Fellini, Howard Hughes, Sergio Leone, David Lynch, Hayao Miyazaki, John Singleton, and Steven Soderbergh.

ASTRO-INFO

For masters of impeccable comic timing, look no further than Capricorn ladies. Betty White, Mary Tyler Moore, Julia Louis-Dreyfus, Tracey Ullman, and Kate McKinnon were all born under the sign of the goat.

Capricorn Crowd-Pleasers

COAL MINER'S DAUGHTER

(1980)

Singer/songwriter Loretta Lynn hand-picked Capricorn actress Sissy Spacek to play her in this rags-to-riches biopic that follows Lynn from the coal mines of Kentucky all the way to the Grand Ole Opry. With realism and dignity, director Michael Apted tells the tale of a woman whose talent and drive propelled her from obscure country-girl to music legend. But her climb wasn't quick or easy—Lynn married at fifteen (Tommy Lee Jones plays her husband), had four children by age nineteen, and suffered a nervous break-down onstage at the height of her fame. Demonstrating the dedication typical of her sign, Spacek never once broke character during filming. She also did her own singing in the movie, and scored an Academy Award for her incredibly authentic portrayal. A true Capricorn triumph.

Sissy Spacek was cast by Loretta Lynn in *Coal Miner's Daughter*. OPPOSITE: DJay (Terrence Howard) dreams of success in *Hustle & Flow*.

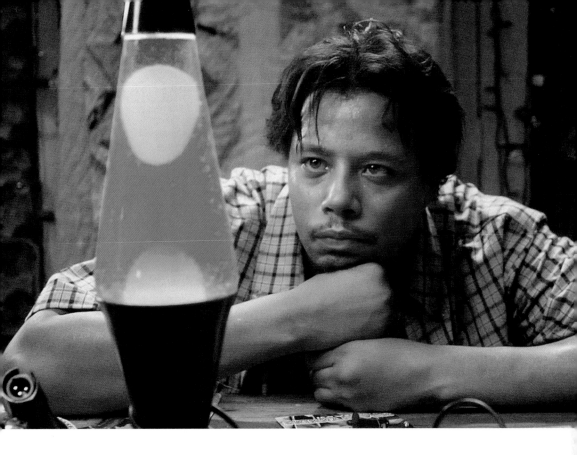

HUSTLE & FLOW
(2005)

When indie filmmaker Craig Brewer wrote the script for this Southern hip-hop Cinderella story, movie studios failed to see its commercial appeal. It wasn't until Capricorn visionary (and *Boyz n the Hood* [1991] director) John Singleton signed on as producer that *Hustle & Flow* started flowing. Singleton and Brewer's underdog battle is mirrored onscreen: DJay (Terrence Howard) is a Memphis pimp with little going for him except ambition. "You ain't never gonna be nothing more than what you is right now," the world tells him, but DJay keeps hustling until his voice is heard. When he succeeds as a rap artist, he empowers a young prostitute (Taryn Manning) to improve her fortune as well. Everyone wins in this scenario, including the movie, which raked in massive profits and critical praise. Keep hustlin', Caps.

Capricorn Date Movies

WORKING GIRL
(1988)

Melanie Griffith's Tess McGill is quite a Capricorn character. In Mike Nichols's deliciously '80s romantic comedy, Tess reinvents the rules of office politics as she transforms herself from struggling secretary to business executive. Relying on brains, determination, and just a touch of deception, this working girl swipes her boss's office and her boyfriend (Harrison Ford) in an all-out effort to take her life to the next level. As they get lovey-dovey over briefcases and business meetings, Griffith and Ford make a successfully sexy duo, encouraging each other's career goals and accomplishing more together than they did apart. It's a Reagan-era love story that still resonates.

A PLACE IN THE SUN
(1951)

There's nothing wrong with aspiring for something better than what we have. It's not only essential to the Capricorn nature; it's the American Dream. But trouble brews when we take shortcuts in our haste to upgrade, which is what eager factory-worker George (Montgomery Clift) does in George Stevens's sensual melodrama *A Place in the Sun*. The moment George sees doll-faced debutante Angela (Elizabeth Taylor), he's smitten—even though he's promised to marry the needy Alice (Shelley Winters). "I guess I even loved you before I saw you," George tells dream-girl Angela. Indeed, as the stunningly beautiful pair of lovers, Taylor and Clift do seem made for each other. As tragedy encroaches, their exquisite love scenes provide the perfect backdrop for cozying up to your favorite Capricorn.

ABOVE: George Stevens directs Elizabeth Taylor and Montgomery Clift in *A Place in the Sun*. OPPOSITE: In *Working Girl*, Melanie Griffith and Harrison Ford mix business with pleasure.

Capricorn Comedies

ELECTION
(1999)

"Some people say I'm an overachiever," says high school presidential candidate Tracy Flick (Reese Witherspoon), "but I think they're just jealous." In Alexander Payne's scathing satire of American politics, control-freak Tracy is an extreme Capricorn caricature: über-organized, overtly ambitious, and determined to succeed at all costs. As annoying as she is, she's basically right—people *are* jealous. Especially Tracy's social studies teacher, Jim McAllister (Matthew Broderick), whose personal grudge against this perky powerhouse leads him to plot her downfall. But is Tracy the victim or the villain? Cap viewers can debate this point during lulls in the laughter over Witherspoon's hilarious (and now iconic) performance. Pair this flick with some of Tracy's "Pick Flick" chocolate cupcakes.

INTOLERABLE CRUELTY
(2003)

Hardhearted divorcée Marylin Rexroth (Catherine Zeta-Jones) and cynical divorce attorney Miles Massey (George Clooney) are both too cold and calculating to be struck by Cupid's arrow. Marylin plans marriages she knows will fail in order to get rich off the settlements, while Miles believes marriage is based on compromise, which, to him, "means death." Let's face it: These two are perfect for each other. In Joel and Ethan Coen's snappy rom-com, Clooney and Zeta-Jones go toe to toe, generating both comical and chemical sparks. "You may think you're tough," Marylin warns Miles, "but I eat men like you for breakfast." Miles is not deterred, but intrigued. "Obscene wealth becomes you," he gushes. Come for the Capricorn-centric laughs, stay to see if true love trumps avarice.

George Clooney and Catherine Zeta-Jones in *Intolerable Cruelty*. OPPOSITE: Reese Witherspoon plays a Capricorn caricature in *Election*.

179

Capricorn Cinderella-Story Classics

MR. DEEDS GOES TO TOWN
(1936)

Capricorns may yearn to be rich and famous, but they want to work for it, not to be handed wealth on a silver platter. When small-town greeting-card poet Longfellow Deeds (Gary Cooper) inherits millions overnight, scads of problems ensue. His new Manhattan mansion is too big for comfort. Servants and bodyguards cramp his style. His tuba-playing routine is disrupted. His business managers try to swindle him. At least he can trust his kindhearted new girlfriend Mary (Jean Arthur)—or can he? Frank Capra's comic comment on money and madness earned him an Oscar for Best Director, and it remains essential viewing today. Does Mr. Deeds keep the millions, the mansion, and Mary? What would *you* do, Capricorn?

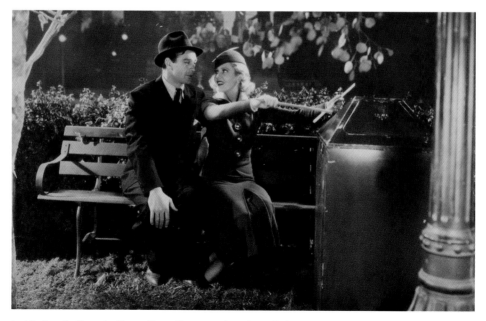

In *Mr. Deeds Goes to Town*, Gary Cooper takes Jean Arthur on a no-frills date to Central Park. OPPOSITE: Julie Christie grows bored with Dirk Bogarde in *Darling*.

DARLING
(1965)

Julie Christie snagged an Oscar for her ebullient performance as a rapacious model/ actress in John Schlesinger's wry statement on fame and decadence. As Diana Scott (Christie) ascends from middle-class London schoolgirl to darling of swinging '60s society, she leaves a trail of used men in her wake. But she's so bloody charming and insouciant while she does it, she's impossible to hate. After throwing over her first husband for handsome Dirk Bogarde, she kicks Dirk aside for dashing Laurence Harvey, and gets everyone's goat by being just a tad too self-serving. But will this cover girl for *Ideal Woman* magazine ever find peace? "I always feel as if there's one more corner to turn," Diana says. Capricorns will relate to her initiative.

Continued Viewing for Capricorn

BLONDE VENUS (1932)

DANCE, GIRL, DANCE (1940)

THE TREASURE OF THE SIERRA MADRE (1948)

ALL ABOUT EVE (1950)

HOW TO MARRY A MILLIONAIRE (1953)

THE MAN IN THE GRAY FLANNEL SUIT (1956)

HOW TO SUCCEED IN BUSINESS WITHOUT REALLY TRYING (1965)

RISKY BUSINESS (1983)

DEAD OF WINTER (1987)

MALCOLM X (1992)

BOILER ROOM (2000)

THERE WILL BE BLOOD (2007)

SLUMDOG MILLIONAIRE (2008)

CREED (2015)

HUSTLERS (2019)

⇒ CAPRICORN HIDDEN GEM ⇐

Caps, if you're looking for a one-of-a-kind cinematic experience, watch *The Man Who Fell to Earth* (1976), a hypnotic science-fiction drama starring rocker/actor (and Capricorn) David Bowie. As an alien who rakes in big bucks as a mogul on earth, Bowie experiences the downside of capitalism amid eye-dazzling imagery.

PARTNERING UP WITH
CAPRICORN

Wondering what to pick if you're watching with a movie buddy or significant other? Wonder no more!

CAPRICORN AND ARIES
Cinderella Man
(2005)

Russell Crowe brings his Aries fire to this true tale of a washed-up boxer who wages a lucrative Capricornian comeback during the Great Depression.

CAPRICORN AND GEMINI
Duplicity
(2009)

What do Caps and Gems have in common? Very little, but both will savor this clever caper about corporate spies who team up to get rich together.

CAPRICORN AND TAURUS
The Barefoot Contessa
(1954)

That earthy Capricorn sex appeal just oozes from Ava Gardner as a gypsy dancer whose life reaches Taurus-level opulence when she becomes a big star.

CAPRICORN AND CANCER
They Shall Not Grow Old
(2018)

Peter Jackson's updated look at World War I will appeal to Capricorn, who honors the sacrifices of our forefathers, and Cancer, who soaks up history.

CAPRICORN AND LEO
The Disaster Artist
(2017)

Wannabe filmmaker Tommy Wiseau's talent can't quite match his Capricorn-level aspirations in this fact-based showbiz comedy from actor/director James Franco.

OPPOSITE: Success leaves Capricorn David Bowie cold in *The Man Who Fell to Earth*.

CAPRICORN AND VIRGO
Casablanca
(1942)

Here's looking at Capricorn megastar Humphrey Bogart and Virgo lovely Ingrid Bergman, two earth signs making movie history together.

CAPRICORN AND LIBRA
The Talented Mr. Ripley
(1999)

Libran Matt Damon is Tom Ripley, an opportunist who strives to be one of the elite, in this stylish adaptation of Capricorn author Patricia Highsmith's novel.

CAPRICORN AND SCORPIO
Mr. Brooks
(2007)

As a wealthy businessman with a hidden penchant for killing, Cap Kevin Costner is gruesome enough to please scorpions, yet methodical and organized for the goats.

CAPRICORN AND SAGITTARIUS
No Country for Old Men
(2007)

The barren mesas of Texas set the stage for this slow-paced chase film. Javier Bardem's grim determination will please Cap; Sag will love the wide-open locales and ironic Coen Brothers humor.

CAPRICORN AND AQUARIUS
Suspicion
(1941)

Legendary leading man Cary Grant's slightly unattainable guy-goat allure (and dimpled chin) lands him a wealthy wife in this Hitchcock thriller. Then he spends her money to avoid being tied down to a job (how Aquarian).

CAPRICORN AND PISCES
All the Real Girls
(2003)

Capricorn actress Zooey Deschanel rides a Pisces-deep emotional wave of first love in this tender art-house romance.

See also the eleven other "Partnering Up" sections for more sign-compatible recommendations.

CAPRICORN STARS

HUMPHREY BOGART
(December 25)

CARY GRANT
(January 18)

NICOLAS CAGE
(January 7)

ANTHONY HOPKINS
(December 31)

JIM CARREY
(January 17)

JAMES EARL JONES
(January 17)

BRADLEY COOPER
(January 5)

DIANE KEATON
(January 5)

KEVIN COSTNER
(January 18)

JUDE LAW
(December 29)

MARLENE DIETRICH
(December 27)

JARED LETO
(December 26)

FAYE DUNAWAY
(January 14)

MARY TYLER MOORE
(December 29)

RALPH FIENNES
(December 22)

ELVIS PRESLEY
(January 8)

AVA GARDNER
(December 24)

MAGGIE SMITH
(December 28)

CUBA GOODING JR.
(January 2)

DENZEL WASHINGTON
(December 28)

AQUARIUS

JANUARY 21–FEBRUARY 19

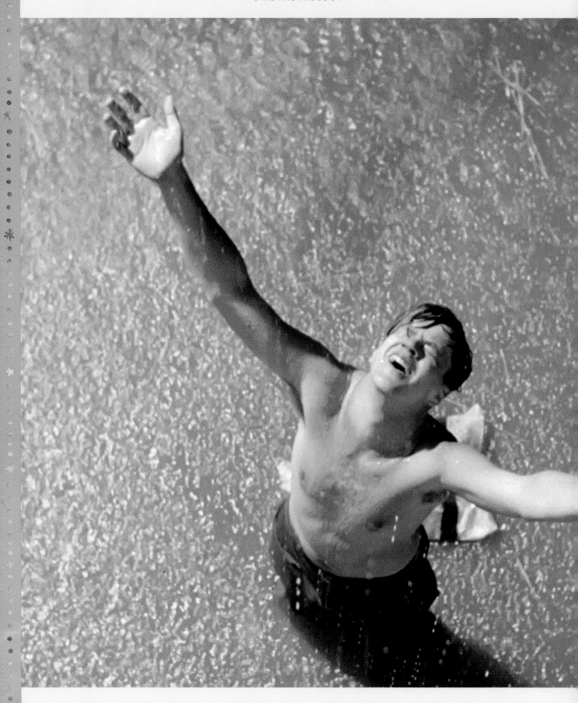

FREEDOM, ORIGINALITY, AND PROGRESS

are the hallmarks of Aquarius the water-bearer, an air sign ruled by the rebel planet Uranus. Dead-set on doing things in their own unique (some might say eccentric) way, water-bearers are the radicals of the zodiac, the idea-generators and innovators. All air signs (Gemini, Libra, and Aquarius) are social, but Aquarius will only commit to relationships that don't fence them in. A common misconception is that the water-bearer relates to the element of water. Not so. Water means emotion, whereas Aquarius is not a particularly emotional sign; though Aquarians care about humanity as a species, they tend to eschew heavy-duty feelings in favor of thoughts and ideas.

Their glyph (a human figure carrying a jug of water) symbolizes the eternally flowing source of all wisdom—the mind. Intellectual, inventive, and often technology-obsessed, the Uranus-ruled embrace cutting-edge trends, whether it's the newest gadget or the latest in digital filmmaking. For a stellar example of Hollywood water-bearers, think James Dean, who starred in only three movies, but made a lasting impression on the world by crafting his own distinct, novel acting style.

If you're born under the sign of Aquarius, the regular rules don't apply to you, baby. You can't be contained and you won't be chained, meaning you're likely drawn to movies about breaking free. Whether it's an escape from prison, as in *The*

Sweet Aquarian freedom: Tim Robbins in *The Shawshank Redemption*.

189

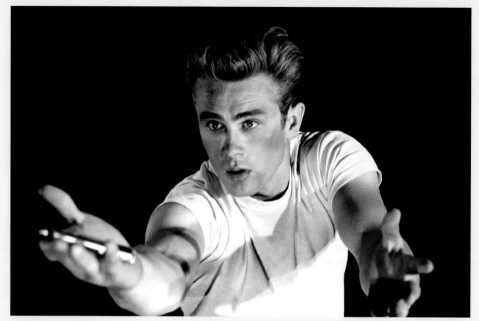

Hollywood rebel (and Aquarius) James Dean.

Shawshank Redemption (1994), from slavery, as in *Django Unchained* (2012), or from addiction, as seen in the Robert Zemeckis drama *Flight* (2012), stories about people shattering the chains that bind them are right up the Aquarius alley.

Water-bearers are fascinated by technology and how it impacts society. *The Social Network* (2010) and *Disconnect* (2012) provide sobering food for tech-thought, while *WALL-E* (2008) and *Robot and Frank* (2012) illustrate the lighter side of the computer revolution. Movies that break new ground in technical innovation are also favorites (think *Star Wars* [1977]), as are films about innovators, those rare visionaries who are unafraid to march to their own drumbeat (think *Dead Poets Society* [1989] and *The Aviator* [2004]).

Aquarius, your forward-thinking ways make you the perfect audience for futuristic science fiction in the vein of *Minority Report* (2002) or *Interstellar* (2014). You're also the most likely sign to see experimental films, because you think outside the box of the standard, predictable Hollywood formula. Wim Wenders's *Paris, Texas* (1984), an offbeat fable about a man drifting alone (Aquarians can be loners), and films by Aquarius auteur Jim Jarmusch—*Mystery Train* (1989) is exemplary—are Aquarius art-house classics. Though

190

David Lynch is technically a Capricorn, his birthday of January 20 puts him on the cusp of Aquarius, and that trademark Uranian eccentricity is apparent in his unusual films: *Eraserhead* (1977), *Blue Velvet* (1986), and *Wild at Heart* (1990), to name a few.

How has that revolutionary Aquarian energy affected the art of motion pictures? For some of the most varied and unique cinematic excursions, observe the output of water-bearer directors Darren Aranofsky, Michael Bay, John Ford, Milos Forman, Christopher Guest, Jack Hill, Tobe Hooper, John Hughes, Jim Jarmusch, Ernst Lubitch, Ida Lupino, Alan Parker, François Truffaut, and Franco Zeffirelli, in addition to the recommendations that follow.

AQUARIUS HIDDEN GEM

Actress-turned-filmmaker Ida Lupino was an Aquarius (born February 4) who bucked the system and defied convention as virtually the only female director in 1950s Hollywood. Catch the suspenseful noir *The Hitch-Hiker* (1953) for one of Lupino's best.

Aquarius filmmaker Ida Lupino directs William Talman in *The Hitch-Hiker*.

Essential Aquarius Extravaganzas

AMADEUS
(1984)

Aquarius-born music maverick Wolfgang Amadeus Mozart (played by Tom Hulce) is vividly brought to life in this semifictionalized biopic by director Milos Forman, also an Aquarius. With Uranus-fueled imagination and ingenuity, Forman skillfully fashions an arresting, passionate (yet never reverent) ode to an iconoclast who lived at least a century ahead of his time. Mozart is much too outspoken, egotistical, and rebellious for late-1700s Vienna, but his brilliant, note-perfect compositions win him royal acclaim, and a dangerous rival in lesser musician Antonio Salieri (F. Murray Abraham). Among heaps of other awards, *Amadeus* won the Oscar for Best Picture, as did another Forman film about nonconformity: *One Flew Over the Cuckoo's Nest* (1975). Watch both back-to-back for an inspiring—if devastating—Aquarius double-feature.

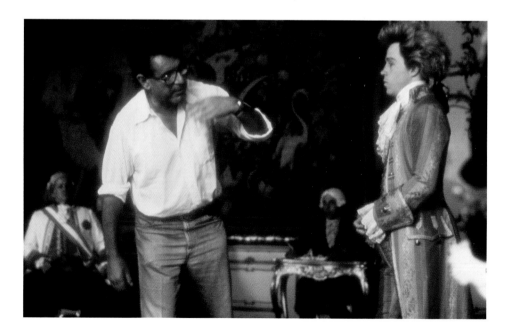

THE MATRIX
(1999)

Aquarius, you're naturally blessed with the individuality and the conviction to stand alone against the herd, to be "The One" who changes everything. As Neo (an anagram for "one"), Keanu Reeves gives new meaning to the term *off the grid* as he boldly breaks free of conformity, unplugs from the sinister machine, and forges a different life in a shockingly stark reality. This cyberpunk smash by the Wachowskis speaks to water-bearers on multiple levels: Its groundbreaking (and heavily mimicked) computer graphics set a new cinematic standard, its mind-blowing plot gives the brain cells a workout, and its underlying message about human rights jibes with those lofty Aquarian ideals. Plus, defying the rules of gravity is so very Aquarius. See Neo, Trinity (Carrie-Ann Moss), and Morpheus (Laurence Fishburne) reinvent the rules when you rediscover the original *Matrix*.

Carrie-Anne Moss and Keanu Reeves fight the establishment in *The Matrix*. OPPOSITE: Milos Forman directs Tom Hulce in *Amadeus*.

193

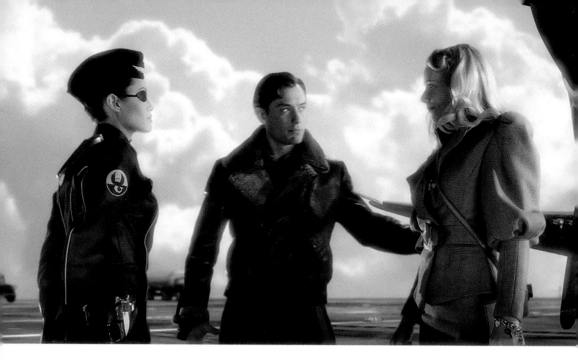

Aquarius Date Movies

SKY CAPTAIN AND THE WORLD
OF TOMORROW
(2004)

Against a glimmering background of technical achievement (*Sky Captain* was the first major movie to be shot entirely against a blue screen), an antagonistic yet sparky romance brews between Jude Law's heroic pilot, Joe, and Gwyneth Paltrow's plucky reporter, Polly Perkins. As they spend time airborne together (in Joe's fighter plane), the two would-be lovers bicker and strive to get along, neither one willing to be vulnerable and reveal their true feelings—which can be difficult for airy Aquarians. After fighting giant robots, discovering the mythical Shangri-La, and narrowly escaping killer machines led by a hologram of Laurence Olivier (hey, it all makes sense in the movie), Polly and Joe's blossoming love barely resembles a friendship. But you get the feeling they'll end up together someday. Perfect for viewing on a friendly first date.

HER

(2013)

Starting as a music-video vanguard and becoming one of the most idiosyncratic auteurs in Hollywood, Spike Jonze is a superstar of the bizarre. In lesser hands, a film about a lonely man in love with a computer operating system could have been a disaster, but writer/director Jonze delivers a surprisingly sweet and genuine story with *Her*. In near-future Los Angeles, sensitive Theodore (Joaquin Phoenix) installs and falls for Samantha (sexily voiced by Scarlett Johansson), a lively, warm source of artificial intelligence that provides just the encouragement he needs to recover from the heartbreak of his divorce. But is Samantha more dependable than a flesh-and-blood lady? Aquarians will applaud this postmodern romance for the digital age.

Joaquin Phoenix has a futuristic love affair in *Her*. OPPOSITE: Angelina Jolie, Jude Law, and Gwyneth Paltrow in *Sky Captain and the World of Tomorrow*.

Aquarius Comedies

FERRIS BUELLER'S DAY OFF
(1986)

This awesome '80s spectacle from Aquarian director John Hughes is all about freedom! Starring Matthew Broderick as a school-ditching teen who does his own thing—from lip-synching the Beatles aboard a parade float to attending a Cubs game instead of gym class—this movie blatantly flouts authority. The coolest thing about Ferris? He's not driven by mere teenage rebellion, but by the fundamental philosophy that everyone is entitled to a day off. And with best-buddy Cameron (Alan Ruck) and the fetching Sloane (Mia Sara) by his side, Ferris has the greatest day of his life on the loose in Chicago. For more Aquarius-appropriate comedies, see the entire John Hughes filmography, including *Sixteen Candles* (1984), *The Breakfast Club* (1985), and *Pretty in Pink* (1986)—all three starring water-bearer Molly Ringwald.

OFFICE SPACE
(1999)

Oh, the burden of having an obnoxious, coffee-slurping boss in your face every morning, demanding your TPS reports. This is just one of the occupational indignities Peter (Ron Livingston) and his cohorts suffer in their daily nine-to-five grind as cubicle-confined Initech employees. But when a hypnosis session goes awry, Peter loses his chronic case of "the Mondays" and gains the confidence to do exactly as he pleases: coming into the office late, playing video games instead of working, and asking a cute waitress (played by Aquarian actress Jennifer Aniston) out on a date. Basically, he becomes an Aquarius. Water-bearers can't abide the monotony of routine, and are known to flee from situations that are too structured. Didn't you get the memo about this?

ABOVE: In *Office Space*, Peter (Ron Livingston) longs to escape his dead-end job. OPPOSITE: Alan Ruck, Mia Sara, and Matthew Broderick break all the rules in *Ferris Bueller's Day Off*.

Ahead-of-Their-Time Aquarius Classics

TROUBLE IN PARADISE
(1932)

This one's for the romantic water-bearers (yes, they exist), seeking an antidote for the predictable boy-meets-girl yarns that we all have memorized by now. In Aquarius filmmaker Ernst Lubitsch's effervescent *Trouble in Paradise*, you'll see the roots of pretty much all subsequent rom-coms, but you'll also be treated to something fresh and fiercely funny. The love triangle between thieves Gaston (Herbert Marshall) and Lily (Miriam Hopkins), and the wealthy Mariette (Kay Francis) feels contemporary nearly ninety years later. Using the light-as-air comic flair that came to be known as the "Lubitsch touch," the German-born director pioneered a new form of screen poetry that is still emulated today (*Trouble in Paradise* was Wes Anderson's inspiration for *The Grand Budapest Hotel* [2014]). Fill your water jugs with champagne for this screening, Aquarians.

2001: A SPACE ODYSSEY
(1968)

Perhaps the most frighteningly realistic vision of the future ever put on film, Stanley Kubrick's magnum opus *2001* tells its story in a remarkably inventive way while advancing the special-effects industry by light-years. It was (and still is) a one-of-a-kind movie. When this sci-fi game-changer hit theaters in 1968 (one year before humans first landed on the moon), audiences weren't sure what to make of it. No major stars appear in it. It begins with a dialogue-free, fifteen-minute sequence about prehistoric apes. Most viewers found its final scenes set on Jupiter to be utterly inscrutable. Yet its world of casual space travel and sentient computers has remained embedded in our collective unconscious for half a century. Open the pod bay doors and screen this one for an Aquarius-level leap into tomorrow.

ABOVE: Keir Dullea takes a ride into the future in *2001: A Space Odyssey*. OPPOSITE: Herbert Marshall and Miriam Hopkins in Ernst Lubitsch's *Trouble in Paradise*.

Continued Viewing for Aquarius

METROPOLIS (1927)

THINGS TO COME (1936)

EAST OF EDEN (1954)

FAHRENHEIT 451 (1966)

LOGAN'S RUN (1976)

KOYAANISQATSI (1982)

THE OUTSIDERS (1983)

AFTER HOURS (1985)

NAKED LUNCH (1991)

TOY STORY (1995)

IRRÉVERSIBLE (2002)

NAPOLEON DYNAMITE (2004)

AQUARIUS (2016)

BLADE RUNNER 2049 (2017)

A QUIET PLACE (2018)

ASTRO-INFO

Who is credited with inventing the first movie camera? An Aquarius, of course. Others had experimented with moving pictures, but Thomas Edison (born February 11) struck gold when he patented the Kinetograph in 1891, effectively kicking off the age of movies.

PARTNERING UP WITH
AQUARIUS

Wondering what to pick if you're watching with a movie buddy or significant other? Wonder no more!

AQUARIUS AND ARIES
Where Eagles Dare
(1969)

This World War II–themed action-adventure has thrills aplenty for Aries; its slightly radical, subversive undercurrents will appease Aquarius.

AQUARIUS AND GEMINI
Galaxy Quest
(1999)

What if a Star Trek–like TV show suddenly became real? The outer-limits mind of Aquarius and the laugh-loving Gemini brain will lap up this comic space-opera.

AQUARIUS AND TAURUS
Blood Diamond
(2006)

While bulls are interested in diamonds for their sparkly material worth, water-bearers wonder who suffered to retrieve them. This thriller has something for both.

AQUARIUS AND CANCER
Butterflies Are Free
(1972)

Free-spirited waif Goldie Hawn cures a blind man of his Cancerian mother fixation in this groovy Age of Aquarius romance.

AQUARIUS AND LEO
Butch Cassidy and the Sundance Kid
(1969)

Pleasing these two opposite signs is easy. Just pop in this buddy blockbuster that teams Aquarius Paul Newman with Leo Robert Redford. Yee-haw!

AQUARIUS AND VIRGO
12 Years a Slave
(2013)

Virgos can endure movies about extreme hardship—which in this case means the horrors of slavery—while water-bearers keep their eyes on the prize of Aquarian freedom.

AQUARIUS AND SAGITTARIUS
Smokey and the Bandit
(1977)

This vehicle (no pun intended) for Aquarius megastar Burt Reynolds provides little substance, but lots of car chases (for road-loving Sagittarians) and the free-wheeling fun of rebellion (for Aquarians).

AQUARIUS AND LIBRA
Harold and Maude
(1971)

Hal Ashby's unorthodox comedy pairs a twenty-something (Bud Cort) and a woman who's pushing eighty (Ruth Gordon). One of the most atypical romances in cinema history.

AQUARIUS AND CAPRICORN
The Searchers
(1956)

Aquarian legend John Ford directs this epic Western about a tenacious old goat (John Wayne) who spends five years scouring the country for his abducted niece.

AQUARIUS AND SCORPIO
The Dead Zone
(1983)

David Cronenberg's eerie thriller may be the most thoughtful, cerebral movie ever made about psychic powers and serial murderers. Water-bearers and scorpions alike will be entranced.

AQUARIUS AND PISCES
Equilibrium
(2002)

Christian Bale (an Aquarius) is intensely credible as a dystopian leader who outlaws all feelings, but cannot suppress his own raging tide of emotions. It's so Aquarius-meets-Pisces.

See also the eleven other "Partnering Up" sections for more sign-compatible recommendations.

AQUARIUS STARS

JENNIFER ANISTON
(February 11)

PAUL NEWMAN
(January 26)

CHRISTIAN BALE
(January 30)

NICK NOLTE
(February 8)

GEENA DAVIS
(January 21)

KIM NOVAK
(February 13)

JAMES DEAN
(February 8)

BURT REYNOLDS
(February 11)

MATT DILLON
(February 18)

MOLLY RINGWALD
(February 18)

MIA FARROW
(February 9)

CHRIS ROCK
(February 7)

FARRAH FAWCETT
(February 2)

JUSTIN TIMBERLAKE
(January 31)

CLARK GABLE
(February 1)

JOHN TRAVOLTA
(February 18)

DIANE LANE
(January 22)

LANA TURNER
(February 8)

JACK LEMMON
(February 8)

OPRAH WINFREY
(January 29)

PISCES

FEBRUARY 20-MARCH 19

APPROPRIATELY, PISCES THE FISH IS THE LAST SIGN OF THE ZODIAC.
These mystical, mutable water babies have such highly evolved souls that they're said to contain elements of all the other eleven signs as well. Governed by dreamy Neptune, Pisces is linked with all forms of fantasy and illusion. Like its symbol of two fish swimming in opposite directions, Pisces natives often lack boundaries; they see the world as their ocean, and nothing is off-limits, from the depths of despair to the heights of ecstasy. Spiritually connected and intuitive, fish can feel vibrations that others ignore, whether psychic or emotional. Like their watery Cancer and Scorpio cousins, Pisces are emotionally tender and tuned into other people's feelings. They're also touched by the creative gods. As long as they avoid the pitfalls of escaping into fantasies or other unhealthy addictions, Pisces people are creatively gifted enough to make their wildest dreams come true, and are happiest when they channel their feelings into music, dance, or other forms of art. As audiences, fish can easily binge on a stack of movies, especially fantasies, romances, and musicals. Their challenge is knowing when to press the STOP button and return to reality.

Pisces, your deep well of empathy allows you to feel the pain of others. You care for your near and dear ones so profoundly, your love can border on self-sacrifice. Movies about making a supreme sacrifice for love like *Camille* (1936), *Brokeback Mountain* (2005), or *Amour* (2012) resonate to the tips of your fins. From the devastatingly romantic *The English Patient* (1996) to the more upbeat *Say Anything* (1989), touching tales of intimate affairs strike a chord with you.

Children of Neptune are fascinated by the extrasensory, the magical, and the unexplained. Scorpio may corner the market on death, but Pisces has the afterlife covered, from the concept of heaven (as in *Field of Dreams* [1989]) to the theory of reincarnation (as in *Cloud Atlas* [2012]) to the notion of disembodied souls (*All of Me* [1984]). Extrasensory perception (ESP) is another Piscean motif, as in *The Eyes of Laura Mars* (1978). Pisces, like a typical fish, you're into oceans, rivers, and lakes, so movies about literal water—think *The Poseidon Adventure* (1972) and *The Shape of Water* (2017)—are your cup of tea.

Musicals really float the Pisces boat. Spectacular sing-alongs like *West Side Story* (1961), *The Sound of Music* (1965), *Across the Universe* (2007), and *Mamma Mia!* (2008)

OPPOSITE: Love means sacrifice for Heath Ledger and Jake Gyllenhaal in *Brokeback Mountain*.

Elisa (Sally Hawkins) cares deeply for a sea creature in *The Shape of Water*.

make for magical movie nights. You may also be drawn down the Yellow Brick Road into the vintage Hollywood musicals of the past, such as *The Wizard of Oz* (1939) or *Going Hollywood* (1933). After all, Hollywood glamour (which is essentially an illusion) is part and parcel to the Neptunian soul, as exemplified by one of the most celebrated screen queens in history, Piscean Elizabeth Taylor.

As filmmakers, Pisceans use their instinct, imagination, and understanding to touch and enlighten humanity on a grand scale. In addition to the recommendations that follow, dip into the movies of Pisces directors Robert Altman, Bernardo Bertolucci, Luc Besson, Luis Buñuel, David Cronenberg, Jonathan Demme, Ron Howard, Spike Lee, Kasi Lemmons, George Miller, Vincente Minnelli, Sam Peckinpah, Rob Reiner, and Sam Taylor-Johnson to see that Neptune magic illustrated onscreen.

⇒ PISCES HIDDEN GEM ⇐

Piscean filmmaker Luis Buñuel was a master at morphing reality and
fantasy into surreal cinematic delicacies. Watch his 1967 coup *Belle
de Jour* (starring a coquettish Catherine Deneuve) to see Buñuel
seamlessly blend mundane moments with flights of fancy, concocting
a world that seems to sway from dreaming to waking and back again.

ABOVE: Catherine Deneuve and Piscean filmmaker Luis Buñuel on the set of *Belle de Jour*

Prime Pisces Picks

THE SIXTH SENSE
(1999)

This is not your typical ghost story. With his momentous feature debut, M. Night Shyamalan flipped the supernatural script with a simple premise: Instead of running from spooky spirits, why not offer them empathy and understanding? That's what gifted Cole Sear (Haley Joel Osment) learns to do when he's visited by child psychologist Malcolm Crowe, played by Bruce Willis. Best known for tough-guy roles at the time, Pisces star Willis proved he's a natural for the emotionally poignant, otherworldly tone of this groundbreaker. You may already be familiar with the twist ending, Pisces, but that doesn't diminish the impact of this story about a kid who not only sees dead people, but helps them transition to the other side. And don't forget the tissues: *The Sixth Sense* may be the most tearjerking thriller ever made.

EVE'S BAYOU
(1997)

Actress Kasi Lemmons (a Pisces) made her writing and directing debut with this sensual reminiscence about Eve (Jurnee Smollett), a precocious ten-year-old girl growing up on the bayou in 1960s Louisiana. When Eve discovers a secret about her father (Samuel L. Jackson) that could destroy her prominent African American family, she reacts both emotionally and imaginatively, becoming confused about what is the truth and what is a lie. *Eve's Bayou* was a sleeper hit, critically lauded for its performances and its deft interweaving of light and dark memories into a rich tapestry. Laced with sultry Southern heat, psychic visions, voodoo, and snakes, this powerful drama positively drips with atmosphere. It's a quintessentially Piscean film.

ABOVE: Jake Smollett and Jurnee Smollett in *Eve's Bayou*. OPPOSITE: Bruce Willis and Haley Joel Osment in *The Sixth Sense*.

Pisces Date Movies

DEAD AGAIN
(1991)

Pisces, when you love someone, you not only hand them your heart on a plate, you throw in your soul, too. Your ideal date movie must delve beyond romantic clichés to illustrate the eternal intertwining of two souls. Enter *Dead Again*, a '90s mystery advertised with the tagline, "How many times can you die for love?" Starring then-husband-and-wife Kenneth Branagh (who also directs) and Emma Thompson as reincarnated lovers, and infused with dark comedy by Robin Williams (as an embittered ex-psychiatrist), the movie ties its twisty plot together with threads of amnesia, hypnosis, destiny, 1940s flashbacks, and a special anklet that makes husband and wife "two halves of the same person." Sure, these two have some toxic past-life karma to work out (spoiler: They literally try to kill each other), but as they say, you always hurt the one you love.

MUSIC AND LYRICS
(2007)

Whether she's acting, producing, or directing, that characteristic compassion shines through in all of Pisces Drew Barrymore's creative endeavors. In the giggly *Music and Lyrics*, this Piscean plays a quirky plant caregiver with a natural gift for writing lyrics. And a lyricist just happens to be exactly what ex-pop-star Alex Fletcher (Virgo Hugh Grant) needs: a poet to help him stage the musical comeback he's been waiting for. When these two opposite signs attract, sparks fly, humor abounds, and they even sing a duet. For a Drew date-night triple-feature, follow up *Music and Lyrics* with *Ever After* (1998), a fresh spin on the Cinderella fairy tale, and *Never Been Kissed* (1999), starring and produced by Barrymore.

ABOVE: Pisces Drew Barrymore and Virgo Hugh Grant make beautiful music together. OPPOSITE: Love never dies for Kenneth Branagh and Emma Thompson in *Dead Again*.

Pisces Comedies

DEFENDING YOUR LIFE
(1991)

Q: How do you know you're in heaven? A: Because Meryl Streep is standing beside you, laughing at your jokes. Writer/director/actor Albert Brooks isn't in heaven yet, though. As the recently deceased Daniel, he must defend his life in Judgment City before moving onward and upward. Falling for the angelic Julia (Streep) doesn't raise Daniel's confidence; she's so good, she makes him look like a cowardly creep by comparison. In Brooks's comic take on the afterlife, everyone has to wear the same white tunics, but on the plus side, you can eat anything you want without gaining weight (no boundaries, Pisces!). Tackling death, love, fear, religion, reincarnation, and morality with laughter instead of tears, *Defending Your Life* makes for a surprisingly encouraging escapade. Keep your eyes peeled for Shirley MacLaine at the Past Lives Pavilion.

THEY MIGHT BE GIANTS

(1971)

If you can track down this long-lost '70s oddity, Pisces, you're in for a treat. It's one of precious few films in which the dreamers, poets, and misfits of the world are depicted as heroic—if only for a few shining moments. Justin (George C. Scott) is a heartbroken hero living inside his own imagination. He firmly believes he's Sherlock Holmes, and when he meets psychiatrist Dr. Watson (Piscean Joanne Woodward), he suspects she might be the sidekick he needs to solve the toughest mystery yet: Why is there so much tragedy in the world? Soon, the doctor joins in her patient's delusion, and a delicately funny love letter to lunacy ensues. The movie's epilogue says it all: "The heart knows things that the mind does not begin to understand." Here's to the all-knowing Pisces heart.

In *They Might Be Giants*, George C. Scott and Joanne Woodward choose illusion over reality. OPPOSITE: Laughter in the hereafter: Meryl Streep and Albert Brooks in *Defending Your Life*.

Paranormal Pisces Classics

THE GHOST AND MRS. MUIR
(1947)

Falling in love with a disembodied spirit is such a Pisces move. In this ethereal delight by Joseph L. Mankiewicz, young widow Lucy Muir (Gene Tierney) experiences a more fulfilling relationship with the ghost of a sea captain (Rex Harrison) than she ever had with any living man. When Lucy rents a haunted cottage by the sea, these two kindred souls meet, live together happily, and forge an unearthly bond that death cannot sever. Curiously, two years before *The Ghost and Mrs. Muir*, Rex Harrison had portrayed a man married to a ghost in the cheeky comedy *Blithe Spirit* (1945). Rent both for a transcendent cinematic séance.

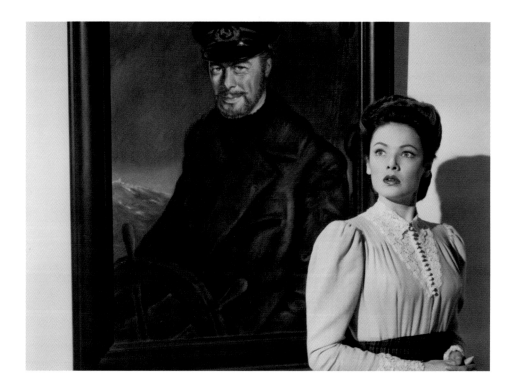

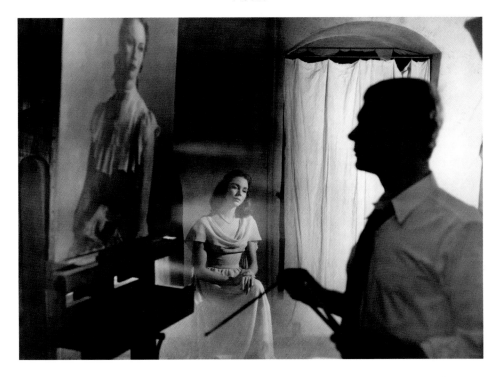

PORTRAIT OF JENNIE
(1948)

"There is no life, my darling, until you love and have been loved. And then there is no death." So says elusive muse Jennie (Jennifer Jones) to lonely, tormented artist Eben (Joseph Cotten) in the unforgettable romance *Portrait of Jennie*. But can Eben and Jennie ever find happiness when they exist in different worlds? Is she even real, or is she a figment of his imagination? The beautiful but troubled Jones (a Pisces, born March 2) was the real-life muse of her husband, *Gone with the Wind* producer David O. Selznick, and this dreamlike production was his tribute to her. Though the film was a financial failure, this haunting Oscar-winner paints a Piscean portrait for the ages.

ABOVE: In *Portrait of Jennie*, Eben (Joseph Cotten, right) immortalizes a woman from another time period (Jennifer Jones). OPPOSITE: Gene Tierney communes with the spirit world in *The Ghost and Mrs. Muir*.

217

Continued Viewing for Pisces

THE PIRATE (1948)

HARVEY (1950)

NIGHT TIDE (1961)

THEY SHOOT HORSES, DON'T THEY? (1969)

ON A CLEAR DAY YOU CAN SEE FOREVER (1970)

CABARET (1972)

DON'T LOOK NOW (1973)

THE PURPLE ROSE OF CAIRO (1985)

WINGS OF DESIRE (1987)

OPEN YOUR EYES (*ABRE LOS OJOS*, 1997) and
its remake *VANILLA SKY* (2001)

THE LORD OF THE RINGS series (2001-2003)

THE FOUNTAIN (2006)

THE FAULT IN OUR STARS (2014)

BEAUTY AND THE BEAST (2017)

CATS (2019)

ASTRO-INFO

● ● ● ✱ ● ● ●

While Leo is associated with the Hollywood entertainment industry, Pisces is the sign linked to the Neptunian art form of motion pictures. Since the early silent days, the illusion of light and shadow that is known as "the movies" has been designated as Neptune's realm.

PARTNERING UP WITH
PISCES

*Wondering what to pick if you're watching with a movie buddy or significant other?
Wonder no more!*

PISCES AND ARIES
Charade
(1963)

Aries Stanley Donen's fast-paced and funny romantic adventure pairs charming Cary Grant with graceful Audrey Hepburn. Who wouldn't fall in love?

PISCES AND GEMINI
Love and Mercy
(2014)

This poignant glimpse into Gemini music legend Brian Wilson's battle with mental illness boasts plenty of heart, soul, and Beach Boys tunes.

PISCES AND TAURUS
Phantom Thread
(2017)

In this intoxicating romance, Taurus Daniel Day-Lewis gives his final performance before announcing his retirement from films as a couturier whose orderly life veers off track when he falls for an emotionally controlling waitress.

PISCES AND CANCER
The Little Mermaid
(1989)

Fish and crabs will find comfort in the joys and sacrifices of mermaid Ariel and her crustacean cohort, Sebastian. Throw in some Oscar-winning songs and you can't go wrong.

PISCES AND LEO
Filmworker
(2017)

Working in the shadow of brilliant but demanding Leo director Stanley Kubrick, assistant Leon Vitali sacrificed his own desires to bring Kubrick's vision to the world. A documentary fish and lions will both appreciate.

PISCES AND VIRGO
Waking Life
(2001)

Slipping between the bounds of reality and illusion in an intelligent and analytical way, this animated breakthrough from Richard Linklater has Pisces and Virgo written all over it.

PISCES AND SAGITTARIUS
The Last Temptation of Christ
(1988)

Pisceans and Sagittarians both enjoy entertainment that explores spirituality and religion. Martin Scorsese's controversial drama is a passionately made epic concerning a very human Jesus Christ.

PISCES AND LIBRA
When Harry Met Sally
(1989)

Pisces buddies Billy Crystal and Rob Reiner are evolved enough to know that the only lasting love starts as friendship—and that's what this relationship-centered rom-com is all about.

PISCES AND CAPRICORN
Liar Liar
(1994)

Trust me on this one: Fish and goats alike will find it impossible not to laugh at this comedy about a smooth-talking lawyer (Capricorn Jim Carrey) who is magically made to tell the truth.

PISCES AND SCORPIO
In the Heat of the Night
(1967)

Acclaimed Pisces superstar Sidney Poitier tackles a mess of murder and corruption down South in this must-see Best Picture winner.

PISCES AND AQUARIUS
Ghost World
(2001)

This above-average, teen-angst trip is cerebral and eccentric (for you, Aquarius) while also emotionally perceptive (you listening, Pisces?). Plus, it's replete with subtle humor.

See also the eleven other "Partnering Up" sections for more sign-compatible recommendations.

PISCES STARS

DREW BARRYMORE
(February 22)

EMILY BLUNT
(February 23)

MICHAEL CAINE
(March 14)

GLENN CLOSE
(March 19)

DANIEL CRAIG
(March 2)

BILLY CRYSTAL
(March 14)

JEAN HARLOW
(March 3)

TERRENCE HOWARD
(March 11)

QUEEN LATIFAH
(March 18)

ROB LOWE
(March 17)

WILLIAM H. MACY
(March 13)

LIZA MINNELLI
(March 12)

LUPITA NYONG'O
(March 1)

SIDNEY POITIER
(February 20)

ALAN RICKMAN
(February 21)

KURT RUSSELL
(March 17)

SHARON STONE
(March 10)

ELIZABETH TAYLOR
(February 28)

BRUCE WILLIS
(March 19)

JOANNE WOODWARD
(February 27)

REFERENCES

Blake, Gene. "Names? Only Zodiac Signs Count at Party." *Los Angeles Times*, October 17, 1959.

Burke, Tom. "'Mean Streets' Leads Scorsese Up New Avenues." *Los Angeles Times*, June 9, 1974.

Champlin, Charles. "'Thomas Crown Affair' at Grauman's." *Los Angeles Times*, June 28, 1968.

Corliss, Richard. "Wes Anderson's *The Grand Budapest Hotel*: Make That 'The Great.'" *Time*, March 10, 2014.

Ebert, Roger. "Lock, Stock and Two Smoking Barrels." *Rogerebert.com*, March 12, 1999. Accessed April 18, 2019. https://www.rogerebert.com/reviews/lock-stock-and-two-smoking-barrels-1999/.

Fiery, Ann. *The Book of Divination*. San Francisco: Chronicle Books, 1999.

Folkart, Burt A. "Obituaries: The Gregarious Aquarius: Carroll Righter, 88; Dean of Astrologers." *Los Angeles Times*, May 3, 1988. Accessed August 1, 2019. https://www.latimes.com/archives/la-xpm-1988-05-03-mn-1951-story.html/.

Hyams, Joe. "Why Is Hollywood Horoscope Happy?" *Los Angeles Times*, April 22, 1962.

King, Susan. "*Romancing the Stone* at 35." *Variety*, March 30, 2019. Accessed July 2, 2019. https://variety.com/2019/film/features/romancing-the-stone-35-anniversary-michael-douglas-1203175725/.

Parker, Julia and Derek. *Parkers' Astrology*. New York: Dorling Kindersley, 1991.

Radloff, Jessica. "Demi Moore Reveals Why She Thought *Ghost* 'Was a Recipe for Disaster.'" *Glamour*, April 25, 2013. Accessed June 20, 2019. https://www.glamour.com/story/demi-moore-reveals-why-she-tho/.

Wilson, Owen. "Interviews." Disc 2. *The Royal Tenenbaums*, DVD. Directed by Wes Anderson. The Criterion Collection, 2002.

https://aficatalog.afi.com

www.astrotheme.com

www.imdb.com

www.rottentomatoes.com

www.wikipedia.org

INDEX

H

Hackman, Gene, 67
Hail, Caesar! 94
Hall, Rebecca, 33
Hallstrom, Lasse, 46
Hamill, Mark, 131
Hamilton, Scott, 125
Hamlet, 101
Hanks, Tom, 4, 49, 64, 75, 77, 120, 147, 166
Hannah, Daryl, 167
Hanson, Curtis, 11, 138
Happiness, 119
Harding, Tonya, 75
Hardwicke, Catherine, 118
Hardy, Thomas, 40
Harlow, Jean, 154, 221
Harold and Maude, 202
Harriet Craig, 109
Harring, Elena, 45
Harris, Neil Patrick, 59
Harrison, Rex, 216
Harry Potter and the Prisoner of Azkaban, 103
Hart, Kevin, 77
Hart, Miranda, 53
Harvey, 218
Harvey, Laurence, 181
Harvey Girls, The, 163
Hathaway, Anne, 149
Hawke, Ethan, 149
Hawkins, Sally, 208
Hawks, Howard, 46, 55, 58
Hawn, Goldie, 148, 149, 201
Hayek, Salma, 113
Hayes, John Michael, 144
Hayworth, Rita, 116–117, 118, 131
Hazanavicius, Michel, 69
Heavenly Body, The, 3
Heckerling, Amy, 29, 124
Heder, Jon, 125
Heiress, The, 110
Hell or High Water, 93
Hello, Dolly! 100
Help, The, 57
Hendricks, Christina, 139
Henreid, Paul, 72
Henson, Taraji P., 102, 113

Hepburn, Audrey, 29, 36–37, 41, 154, 219
Hepburn, Katharine, 29, 41, 46–47, 165
Her, 195
Heston, Charlton, 131
Hidden Figures, 102
High Noon, 36
Highsmith, Patricia, 184
Hill, Jack, 191
His Girl Friday, 58
Hitchcock, Alfred, 83, 94, 144, 184
Hitch-Hiker, The, 191
Hoffman, Dustin, 57, 105
Hoffman, Philip Seymour, 130
Holden, William, 18
Hollywoodland, 92
Hooper, Tobe, 191
Hopkins, Anthony, 185
Hopkins, Miriam, 198–199
Horne, Lena, 76–77, 77
Houston, Whitney, 83
How to Marry a Millionaire, 182
How to Steal a Million, 36–37
How to Succeed in Business Without Really Trying, 182
Howard, Ron, 208
Howard, Terrence, 174–175, 221
Hudson, Jennifer, 84–85
Hudson, Kate, 66
Hudson, Rock, 148
Hudsucker Proxy, The, 100
Hughes, Howard, 173
Hughes, John, 154, 191, 196
Hugo, 74
Hulce, Tom, 192–193
Hunt, Helen, 107
Hunter, Holly, 100
Hurt, William, 100
Hurt Locker, The, 10
Hustle & Flow, 174–175
Hustlers, 182
Huston, Angelica, 67
Huston, John, 83

I

I, Tonya, 75
I Heart Huckabees, 58
I Like It Like That, 164
I Love You to Death, 146
I Married a Witch, 147
Ideal Husband, An, 111
I'll Cry Tomorrow, 65
I'm No Angel, 90
Imitation Game, The, 109
Imitation of Life, 65
Immortal Beloved, 40
Importance of Being Earnest, The, 128
In Bruges, 56
In the Heat of the Night, 220
Inception, 20
Indiana Jones movies, 154
Innaritu, Alejandro, 83
Inside Man, 118
Inside Out, 101
Interstellar, 190
Into the Wild, 164
Intolerable Cruelty, 179
Intouchables, The, 109
Iron Man, 83
Irréversible, 200
It Happened One Night, 126–127
It's a Wonderful Life, 73
Ivory, James, 46, 57

J

Jackman, Hugh, 131
Jackson, Peter, 136, 183
Jackson, Samuel L., 167, 211
Jacob's Ladder, 46
Janney, Allison, 53
Jarmusch, Jim, 190, 191
Jaws, 166
Jenkins, Patty, 83
Jerry Maguire, 21
Jeunet, Jean-Pierre, 159
Jewison, Norman, 68, 122
Johansson, Scarlett, 4, 33, 166, 167, 195
John, Elton, 83
Johnson, Dwayne, 41
Johnson, Katherine, 102

Johnson, Rian, 155
Jolie, Angelina, 46, 59, 194
Jones, James Earl, 185
Jones, Jennifer, 217
Jones, Quincy, 14
Jones, Tommy Lee, 113, 174
Jonze, Spike, 118, 195
Joy, 94
Judge, Mike, 118
Jurassic Park, 82, 154

K

Kalra, Viveik, 129
Kaufman, Andy, 4, 173
Kaufman, Charlie, 51
Kaye, Danny, 173
Kazan, Elia, 101
Keaton, Diane, 166, 185
Keaton, Michael, 111, 143
Keeler, Ruby, 90–91
Kelly, Gene, 98–99, 100, 111, 113
Kelly, Grace, 36, 144–145, 149
Kid, The, 73
Kidman, Nicole, 50, 59
Kill Bill Vol. I and *Vol. II*, 19
King, Martin Luther, Jr., 111
King and I, The, 92
King Kong, 82, 162–163
King's Speech, The, 39
Kiss Kiss, Bang Bang, 19
Klugman, Jack, 106
Knightley, Keira, 23, 161
Knowles, Beyoncé, 84–85, 113
Koyaanisqatsi, 200
Kramer, Stanley, 127
Krasinski, John, 118
Kubrick, Stanley, 28, 83, 147, 199, 219
Kung Fu Hustle, 13
Kunis, Mila, 95
Kurosawa, Akira, 11

L

L.A. Confidential, 138–139
La La Land, 20
Lady Gaga, 23, 87

PHOTOGRAPHY CREDITS

Page 12: Courtesy Lionsgate/*Apocalypse Now* Final Cut

Page 67: Courtesy Touchstone Pictures

Page 68: Author's collection

Pages 9, 10, 14, 15, 19, 22, 26, 27, 28, 32, 35, 36, 37, 44, 45, 48, 50, 51, 52, 54, 55, 56, 62, 63, 64, 65, 66, 70, 73, 76, 81, 82, 84, 86, 88, 89, 92, 98, 99, 100, 101, 104, 106, 108, 112, 116, 122, 123, 124, 126, 127, 134, 135, 137, 140, 141, 143, 144, 145, 153, 154, 155, 160, 162, 163, 170, 171, 172, 174, 176, 177, 178, 180, 181, 182, 191, 192, 193, 196, 198, 199, 207, 209, 210, 212, 214, 215, 216, 217: Courtesy Independent Visions Archive

Images from the Independent Visions Archive are exclusively represented by mptv. For more information regarding licensing or purchasing images from mptv, please contact mptvimages at www.mptvimages.com.

The photos and images in this book are for educational purposes, and while every effort has been made to identify the proper photographer and/or copyright holders, some photos had no accreditation. In these cases, if proper credit and/or copyright is discovered, credits will be added in subsequent printings.

ACKNOWLEDGEMENTS

Sincere thanks to all the multi-talented people behind *Cinemastrology*.

Where would this book be without the dependable, devoted, and caring Taurus presence of editor Cindy Sipala? It would still be floating among the stars, a vague concept without material form or a good title. Thank you, Cindy.

Without the Piscean vision and creative touch of Manoah Bowman, this book would be severely lacking in imaginative, high-quality imagery. Thank you, Manoah.

Thanks to Gary De Forest for inspiring the Gemini section with her love of espionage and comedy, and to Dilhya Ross for lending a dose of Sagittarian brilliance to the brainstorming process.

Many thanks to the Running Press team, including Susan Van Horn, Katie Manning, Kristin Kiser, Jennifer Kasius, and Seta Zink. I am also grateful to Zoe Wodarz for her clever and whimsical illustrations.

Much gratitude to the dozens of wise astrologers who have informed my knowledge of the subject for the past twenty-five years.

A special thank-you to the Los Angeles Public Library System.